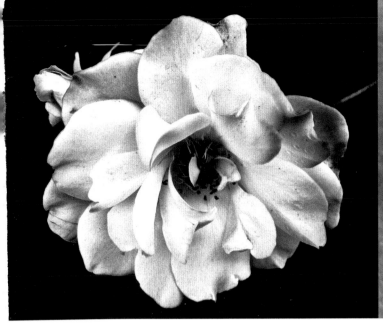

Phone Photography for Everybody
Still Life Techniques
for iPhone, Android & All Smartphones

Create
Pro Quality
Images

Beth Alesse

Beth Alesse is an author, photographer, graphic and digital artist, and editor. In addition to writing, she curates image collections to present in books and media productions. She holds degrees in art and education, and has a broad background in graphic arts, linguistics, and visual and digital media.

Her books with Amherst Media include *The Moon*, *The Earth: A Visual Story of Our Amazing Planet*, *The Sun: NASA Images from Space* and *Hubble in Space: NASA Images of Planets, Stars, Galaxies, Nebulae, Black Holes, Dark Matter, & More.*

Published by:
Amherst Media, Inc.
P.O. Box 538
Buffalo, N.Y. 14213
www.AmherstMedia.com

Publisher: Craig Alesse
Publisher: Katie Kiss
Senior Editor/Production Manager: Barbara A. Lynch-Johnt
Senior Contributing Editor: Michelle Perkins
Editor: Beth Alesse
Acquisitions Editor: Harvey Goldstein
Editorial Assistance from: Carey A. Miller, Roy Bakos, Jen Sexton-Riley, Rebecca Rudell
Business Manager: Sarah Loder
Marketing Associate: Tanya Flickinger

ISBN-13: 978-1-68203-444-6
Library of Congress Control Number: 2020935746
Printed in The United States of America.
10 9 8 7 6 5 4 3 2 1

www.facebook.com/AmherstMediaInc
www.youtube.com/AmherstMedia
www.twitter.com/AmherstMedia

Contents

Still Life Phone Photography5

1 Still Life and Phone Camera Basics6
Using the Phone for Still Lifes8
How to Begin. .10
Explore Your subjects .10
Save Files Often .12
Cloud Storage. .12
Work Between Devices. .12
Phone Camera and Native Apps.14
Essential Photo Refinement14
Out-of-Camera Effects .14
Focusing. .16
Steady the Phone Camera19

2 Still LIfe Vision and Artistic Plan20
Subjects and Themes .22
Objects in Settings .23
Create a Series .25
Complexity Can Convey Mood26
Minimize for Simplicity. .27

3 Still Life and Composition Basics28
Curves and Leading Lines30
Repetition in Still Life .32
Patterns .34
Symmetry. .36
Color .38
Texture .39
Selective Color. .40
Silhouette Still Lifes. .42

4 Still Life Lighting . 44
Sunlight . 44
Diffused Light .46
Window Light .48
Adding Light with an App50
DIY Light Box Back Lighting.53
Candlelight .55
Reflections Casting Images57

5 The Power of Apps .58
Kinds of Apps .58
App with Filters, Layers, and Effects.59
Apps Formulas .63
Black & White Still Life Images65
Mono-Chromatic Apps for Still Lifes67
Vignettes .68

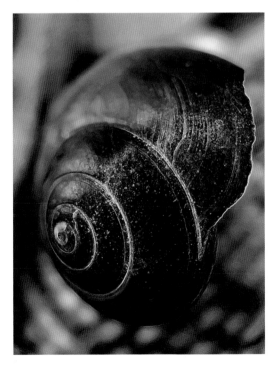

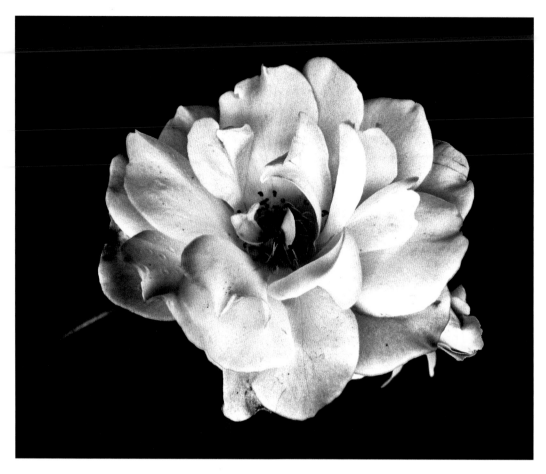

Make Reflections Using an App71
Art Effects .73
Textured Layers .74
Layer Mode .75
Artful-Graffiti Expression in a Still Life76
Photo to Still Life Drawing 178
Photo to Still Life Drawing 281
Photo to Watercolor Still Life83
Photo to Oil Painting Still Life84

6 Masters, Movements,
and Visual Styles86
Impressionism .86
Pop Art .88
Digital Art .89
Surrealism .91
Layered Realism .92
Super Realism .93
Abstract Realism .94
Comic Book Style .96

Art Nouveau .98
Pointillism .101
Stipple Effects .101
Percolator Pizza . 102
Fractured by Movement 104
Print-Like Graphics . 106
Wood Block Prints . 108
Print and Film Era Styles110
Glitch Art Still Lifes .111

7 Still Life Narratives & Stories112
Visual Mysteries, Unraveling a Riddle115
Contrast and Contradiction117
Show the Ordinary .119
Pareidolia .120
More Still Lifes with Personality122
Explore, Create, and Share Your Still Lives124

App List .126
Index .126

Still Life Phone Photography

Everybody can make still life images with their vision and personal sense of creativity using their smartphone cameras or tablets.

Smartphones put a camera in everyone's pocket or bag. It's never been so effortless to make still life images of objects or collections of objects. My tool of choice is the iPhone, but any smartphone can do the job. I have created my images using the iPhone, its apps, and an iPad utilizing the very same apps when a larger screen was needed. Everybody can make still life images with their own vision and personal sense of creativity using their smartphone cameras or tablets. The image of beach glass *(below)* was photographed using an iPhone (model Xs Max) front-facing camera, and most of the images in this book used this same camera. The flower *(facing page)* was taken with an iPad camera. Any smartphone can be used for most of the still life photography techniques in this book. Start with whatever equipment you have and grow from there.

Your still life subjects can be everyday items such as tools, articles of clothing, nuts and bolts, candy, gathered flowers, vegetables, or merchandise. Or they can include unique items, such as, one of a kind curiosities, heirlooms, and natural history finds. Still life photographs can be fascinating and revealing, beautiful or alarming, traditional or trendy in style. This book shows how to easily make successful and intriguing images with techniques that range from shooting to composing to app use, including filters, layering, masking, and more.

BethAlesse@AmherstMedia.com

1 Still Life and Phone Camera Basics

Techniques and examples from traditional to contemporary

Still life is a category of art, where mainly inanimate objects are featured as the subject in an arrangement. This is in contrast to other categories or genres of photography and art such as landscape, portraiture, or story telling where the main subject is, respectively, a scenic view, a specific personal portrayal, or a visual narrative. Yet, artists today creatively blur the lines between artistic genres. Not only do historical trends affect how we make our still life images, the current digital media technology has an enormous influence on how and what we create.

Subjects for still lifes can be singular or within an environment or setting, everyday or unusual. Organic items are often included such as flowers, fruit, and nature's curiosities, but the objects you include are limited only by your imagination.

Historically, still life painting was used by artists to exhibit their proficiency in illustrating the characteristics of objects. Proportions, textures, lighting, reflections, and other technical hurtles needed a degree of painterly skill. When photography took the world by storm in the mid to late 1800s, still life photography became an art in itself. Currently, still life photography and artistic design are used in advertising, illustration, and fine art expression.

The focus of this book is to show a wide range of techniques and examples illustrating the extensive and diverse possibilities for creating still lifes on the iPhone, and most other smartphones and tablets, as well. The techniques include everything from traditional looks to modern styles to totally contemporary digital approaches.

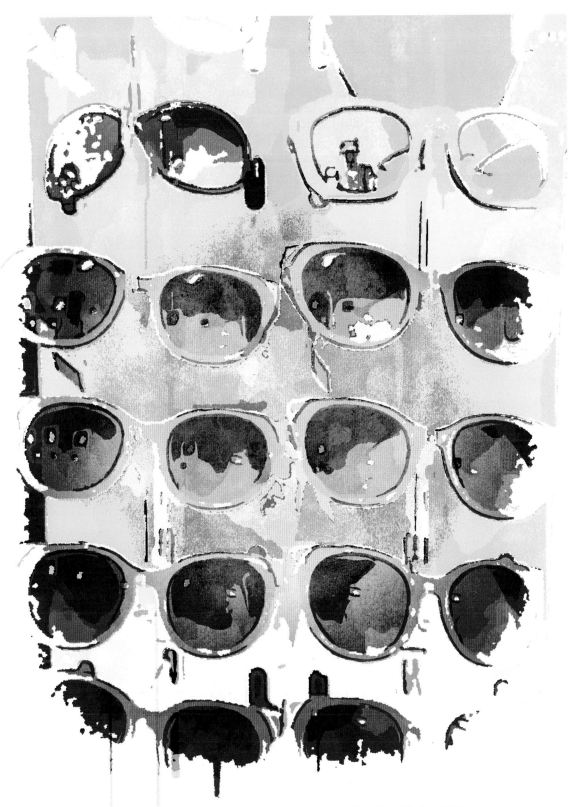

The file for this shot of a sunglass display was opened in the Adobe PS Express app, making several images using different styles. The layers were flattened creating a more vibrant final image.

Using the Phone for Still Lifes

I have worked mainly with the iPhone 6 Plus, iPhone Xs Max,

"Whichever is your iPhone camera model, it has plenty of features to get you started . . ."

and various iPads. The Xs Max is my current iPhone, and although I thought about upgrading, I am really happy with the results of its lenses. The iPhone has an amazing set of camera lenses. Nearly all the images in this book were taken with the iPhone X unless stated otherwise.

I chiefly use the wide-angle, rear-facing camera lens. The telephoto lens comes in handy when I need to bring things in closer that are distant. This lens also has the ability to get a little closer to the subject, such as coins, stamps, and other tiny objects. The innate, or in-built, camera app also has a Portrait selection which combines the two lenses enabling the distance to be thrown into a blur while closer objects remain in focus.

The iPhone with its native camera app is a fantastic photography tool. It is amazingly utilitarian, comprising still photography and video modes

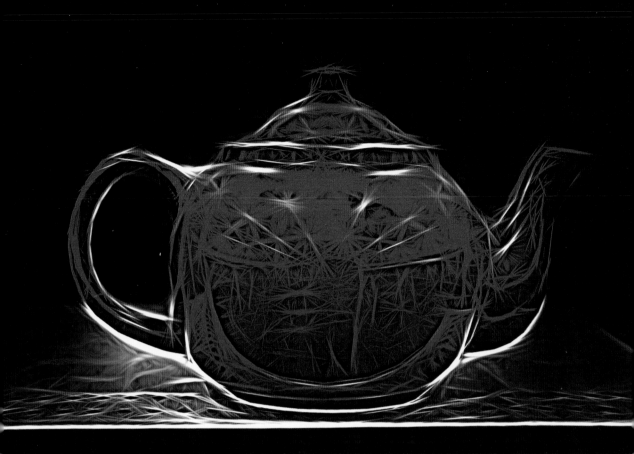

(including slow motion and time lapse). Still photography has options for flash, timer, Live Photos, Portrait mode, panorama, square, filter presets, back-facing lens, and

This image *(above)* was taken inside a thrift store. My intent was to throw the distracting background out of focus using the Portrait selection. Then, I used the Snapseed app to make a vignette that darkened most of the remaining background. Lastly, I used the Tangled FX app to create tangled effects with a great degree of control over several variables *(facing page).* It is a fun app that transforms your still life into something very different than you initial photograph.

two front-facing lenses (one that is a telephoto). The iPhone 11 Pro has a third front facing lens. In the Android camp, Samsung Galaxy and Google Pixel phones (among many other Android phones) have good cameras. Whichever camera you are using, some of the features will get a good deal of use, others will have infrequent use depending on your techniques and workflow. Whichever is your camera choice, your smartphone will have plenty of features to get you started and immersed in the art of still life.

How to Begin

Begin by using the camera you have. Don't worry about having the latest model. As you work, the need for other equipment like a tripod or lens will present itself, but don't let the lack of ideal equipment keep you from starting. Likewise, the still life subjects that are nearby are the best ones to begin with. Each of our worlds are full of interesting objects and collections. Start with what is near by and handy.

Explore Your subjects

Exploring and revisiting your subjects compels you to learn by examining, tweaking, and adjusting. Consider a change of angle, distance, equipment, settings, time of day, stage of plant life, and even a different state of mind. Inspect and ponder your subjects, the arrangements, and the equipment. Let your process develop out of these explorations.

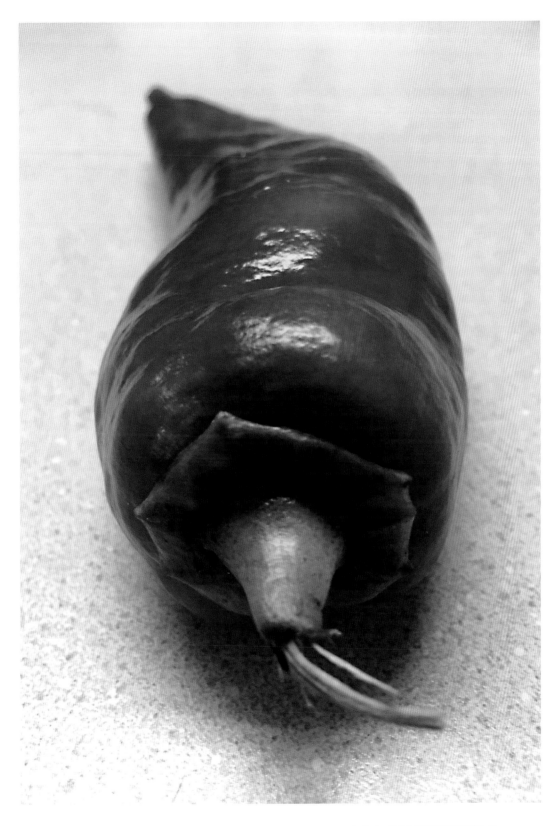

Save Files Often

Save your final images and frequently save your works-in-progress while you are creating them. An app may ask to make changes to the original photo file or to save your work as a new file. A new file is always my choice.

Cloud Storage

No matter what size memory your camera has, it will run out, and you will need to have external storage of some kind. Find in your phone's settings where it will allow work files to be saved to an external cloud address. Cloud storage options for iPhone and Android smartphones include Drop Box, Google Drive, Amazon Drive, and many more. Cloud storage—with automatic upload and download—allows us to photograph to our heart's content without running out of phone memory.

Work Between Devices

Besides using the cloud for storage and transfer, Handoff and Airdrop (both on iPhone) are used to continue work between several devices. I appreciate being able to continue

work on the larger, eye-saving iPad screen with practically all the same apps as my phone.

This image is a shot with the shade with a flood of indirection sunlight. The fruit sat on a stainless steel table that had specular highlights. The light that bounced up was reflected from the table and it highlights the fruit along the shaded side, helping to define its shape. The file was opened in the app SnapDotStipple for its dot effect.

Phone Cameras and Native Apps

Native phone apps—the apps that come with your phone—are very functional. However, you can find other camera apps and editing apps that will have additional helpful adjustments. Some simulate SLR camera adjustments. There is better control of the exposure allowing for blur, grain, low lighting, selective field of focus, compositional guides, levels, and more. You may find the arrangement of one app's adjustments more preferable to another app's adjustments. Likewise, the presets of a particular app may be exceedingly useful to you. Spend a little time getting used to your phone's native camera app, and then, try some more full-featured camera apps.

Essential Photo Refinement

Lightroom, Snapseed, and VSCO, as well as your phone's native photo app, are just a few of the apps that can be used to make adjustments to your still life images. Exposure, white balance, saturation, sharpening, and vibrance are some of the primary adjustments that you will make. Some apps can make these adjustments automatic. Others have selections that have layered filters that tweak these adjustments to create specialized effects.

Out-of-Camera Effects

Don't forget to experiment with the many things that can be done with any camera and without an app. This image *(facing page)* is a still life example with an interesting effect done with a concave magnifying mirror.

This still life image of my iPhone *(facing page)* was shot aiming into a concave magnifying mirror. After opening in the PS Express app, the contrast, luminosity, blacks, and sharpening slightly increased. Because the mirror's reflection reversed the print on the phone screen, I chose "Rotate" and then "Flip Horizontal" before saving to the camera roll.

Focusing

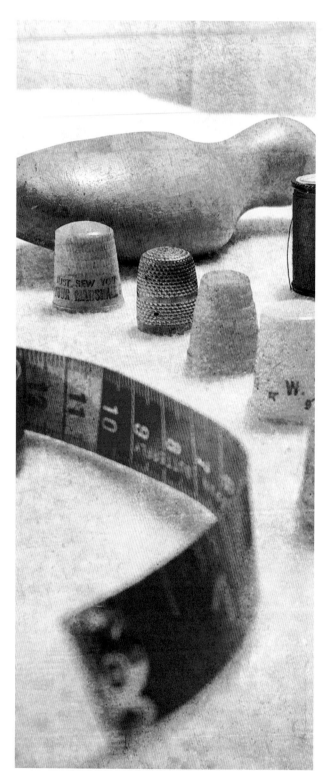

All smartphones have an autofocus and touchscreens that let you select a specific area for focus by tapping on the preferred screen location. Simply tap to focus. On my iPhone, a yellow square frame appears in the focused area. Swiping up and down near this box lets you set the exposure. I can lock the focus to a specific distance with a longer press. After focusing, be careful not to change the distance between the camera and the object of focus. Wherever you place the main subject of your still life is usually where you want the sharpest focus.

Smartphones with a telephoto lens can use this lens to focus more closely. Using a tripod helps maintain focus. Notice the difference between these two images. The first image *(left)* is focused on the background. The second and final still life *(facing page)* is focused in the foreground. Both of these images were processed through the DistressedFX+ app using the Sweetgum and Syn overlays.

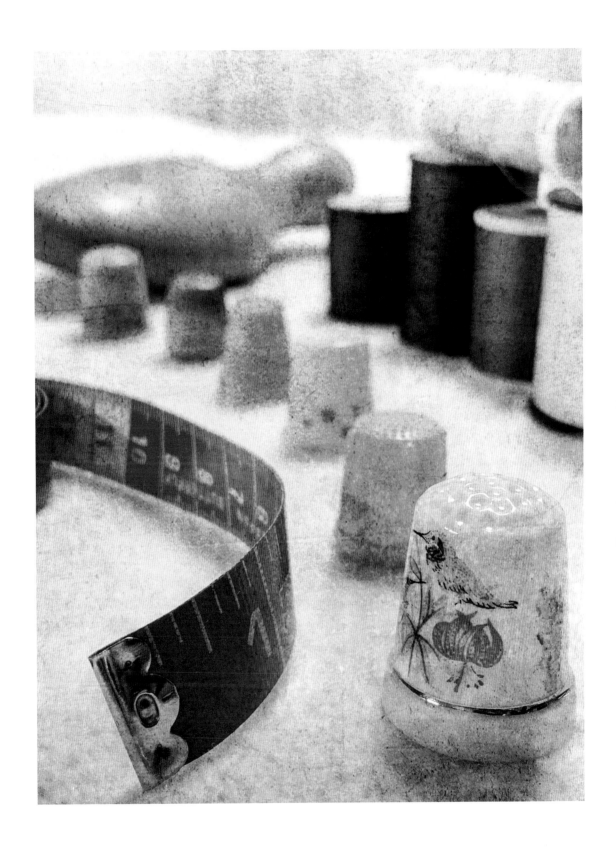

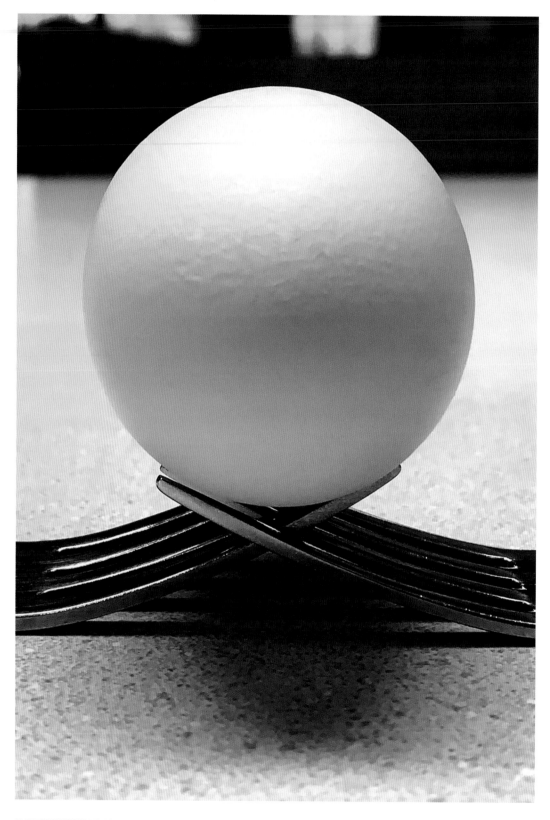

Steady the Phone Camera

Using a tripod can mean the difference between an okay photo and a remarkably sharp and successful one. Low light, close-up shots, wind blowing, macro lenses, and just plain breathing can introduce unwanted camera movement. The subject of your still life can easily be thrown out of focus. A tripod will also allow you to keep the camera steady. Just as important, it gives you the means to have your hands free to arrange the objects in your picture and to add or reposition lights.

Techniques requiring more than one image to be merged together, using one of the many apps that provide a double exposure feature, may need each image to be lined up with precisely the same camera angle and distance. A tripod will facilitate a more precise alignment.

There are many tripods, some costly and some very reasonable, made for use with your phone. However if you find yourself without a tripod, a selfie stick can be used in a pinch. Likewise, propping the phone against a solid object can be used to reduce movement. Additionally using a remote or earbuds to trigger the exposure will eliminate camera shake that can result from your finger touching the screen's shutter icon. Movement can also happen from breathing during a handheld shot. So if you need to hold your phone, especially in low light, hold your breath and lean against something solid when selecting the shutter icon.

This still life image of an egg balanced on forks *(facing page)* was photographed with window light filtered in from behind and in front of the egg. Florescent ceiling light made the image very pink, and this was corrected using Adobe's app Photoshop Fix.

Both the egg image and shell image *(right)* were taken using a tripod to steady the camera.

2 A Still Life Vision and Artistic Plan

An inkling grows into a vision—and that is a very good place to begin.

A still life set up may take longer than you first thought. Decide on the purpose of your still life. Are you creating an image of your product or your family heirlooms? Then, you probably have some good ideas about what you want to do. Do you want to show the subject with other similar items? Or, do you want to spotlight an object on its own? Is your plan to make an image like an impressionistic painting?

The process of still life set up is one of exploration, experimentation, and adjustments until you have several options you are happy to start with. It's important to begin, even if you don't have a specific plan or vision. Collect some objects of interest and a few alternatives, and then put them on your table or platform. With the camera on its tripod, fine tune its position until you see something you like. You see immediately on the phone screen what you will get. You are on the way to fine tuning your still life.

This chapter presents some of the basic points to consider in your still life set-up process. It will help you begin to form a path with easy steps forward.

I brought the hats out from the closet and began to explore their textures. The light, from a large south facing window on a bright but cloudy day, was on the left. I used healing in Adobe's PS Express app to take some lint off the black hat and a stray straw *(above)*.

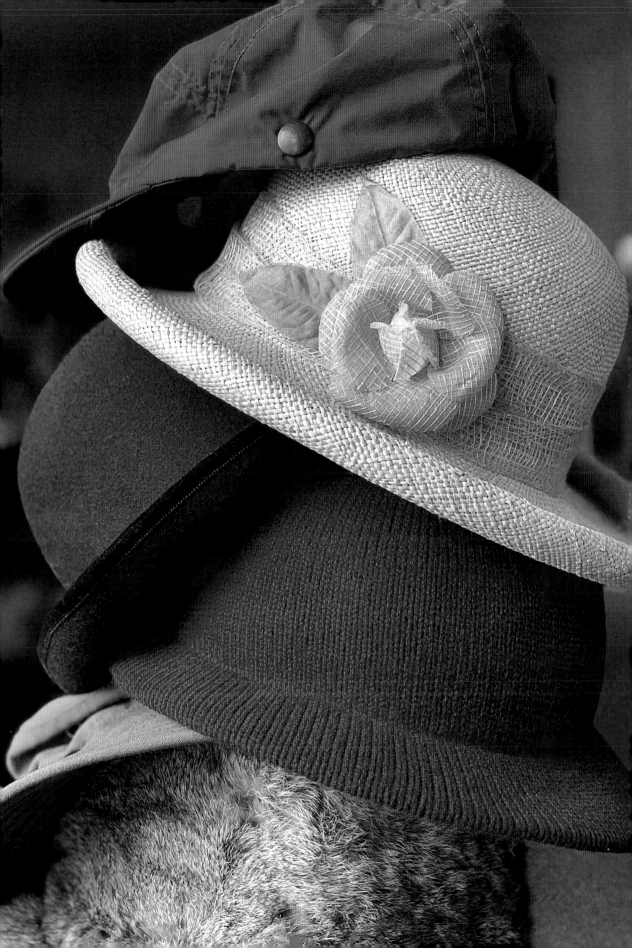

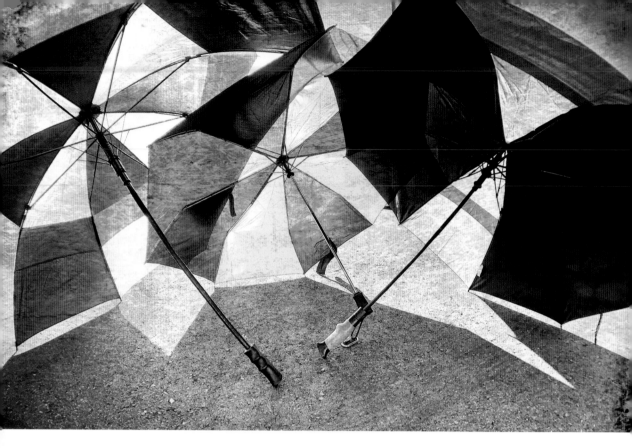

Subjects and Themes

As part of the still life set up process, consider your subject and a theme. A theme can be stated subtly or boldly. Themes help us to identify related objects that make up a still life. For example, one might include antiques from the same era or tools of a by-gone trade. A theme can add consistency, as there will be a cohesive grouping of objects.

Of course, if your purpose is to show the difference between the

This image of opened umbrellas *(above)* was photographed with an iPhone (model Xs Max), front-facing top camera, (1x lens) using a Moment wide-angle lens. The early morning sun was fairly low in the sky as it filtered through the umbrellas. The image was opened in Snapseed and a Grunge filter was applied.

old and the new, including a new Bluetooth gizmo surrounded by old gadgets may be a good plan thereby showing the contrast between the items.

This still life was photographed using a tripod. The image of eye glasses *(right)* is enhanced by making the open book an integral part. It was processed in Snapseed using a grunge filter.

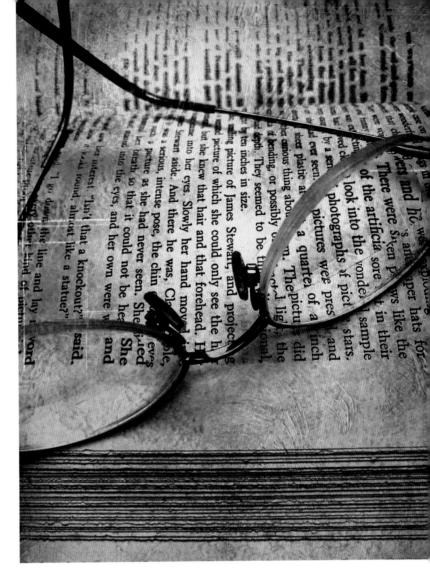

Your still life theme does not need to be based on subject matter. Elements of design and composition such as texture, shape, or color may be what embodies the theme in your work. Your theme may be an abstract concept such as symmetry, proportion, or negative space.

Objects in Settings

As you take your photos, you will see that sometimes the background is as much the subject as the objects.

You may want to minimize the background or deliberately emphasize it. Consider how the background's minor objects contribute to or diminish from the focal objects. Patterns and textures can give richness or detract from the still life subject. Experimentation is key as you get a feel for the interplay between background or setting and the objects in your image.

Create a Series

An artist's approach is more whole-hearted when they work in a series. You, as an artist, can delve into your work more deeply as you produce multiple images. Your understanding and skill in photographing with the smartphone, utilizing the apps, and preforming techniques will develop. The subject may be the same or related, but each worked image can be incredibly different. When creating numerous finished still lifes in a series, you will develop cohesion and unity that articulates into a more mature artistic proficiency.

This series of images was photographed used an early model iPad, back-facing camera.

Complexity Can Convey Mood

Windows can be a great still life subject. The possibilities of their complexity is charming. Sill content, frame material, translucency of glass and screens, a multitude of textures, diverse sources of light and the promise of reflections. Transparent objects are layered with reflections, making interesting compositions that can tell intriguing narratives. Using basic editing controls can tweak these elements to enhance a mood.

This image was photographed using an early model iPad, back-facing camera. The image was refined using an early version of a Photoshop app that is no longer available, but I still find very useful.

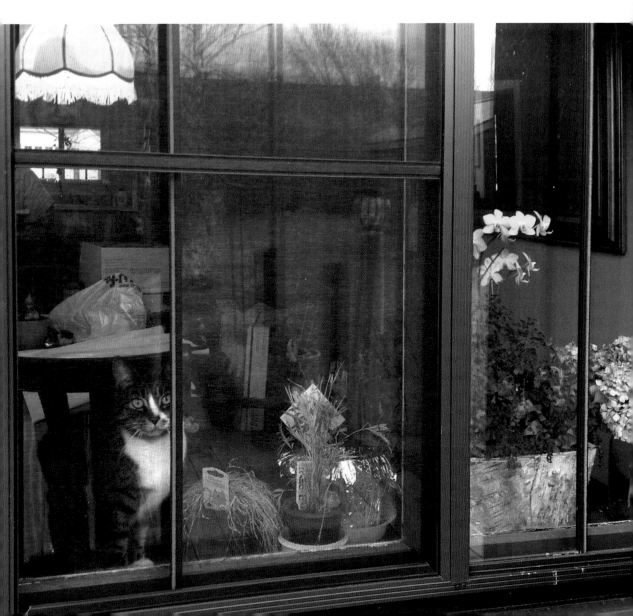

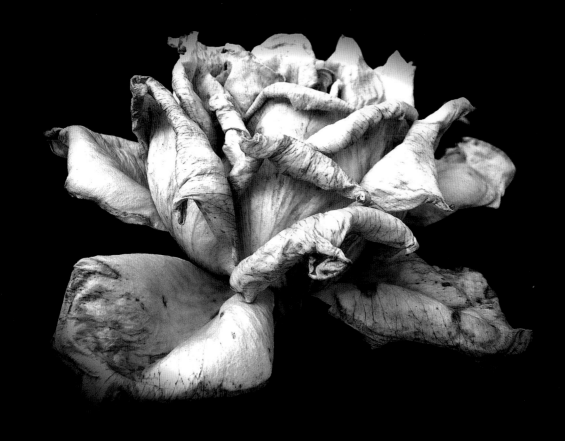

Minimize for Simplicity

Still life subjects can be very simple. The process to produce a simple im-

This still life of a waning rose was photographed using an early model iPad. The flower was silhouetted against green foliage. Using an early version of a Photoshop app, the greens were darkened and a vignette applied to reduce the distracting background.

age may not be so simple in itself. The photograph file of this fading rose from a bouquet was opened in Adobe Photoshop on an iPad. The rose was selected with a feathered ellipse tool, then inverted. Next, everything but the rose was selected and was darkened. A healing brush or paint brush can be used to further blend the background into darkness.

3 Still Life and Composition Basics

Understanding composition helps when taking a photo, and can improve it after when editing.

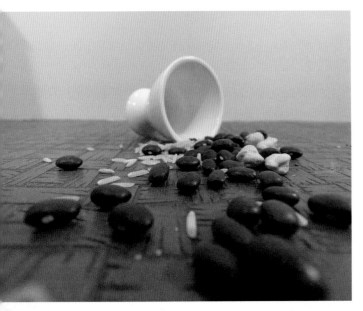

We do our best to take the right photo at the time of exposure. But that doesn't always happen. However, there is a gold mine in our not-always-perfect images. For example, the image *(left)* has an unwanted shadow on the left and a poor composition. To make an improved image the composition can be tweaked by cropping. The two bottom images are overlaid with grids that illustrate

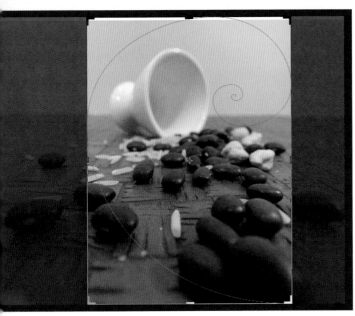

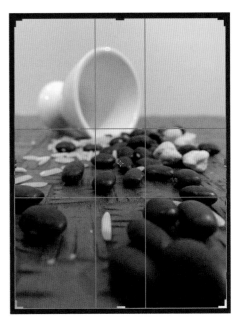

the lines of the golden spiral *(facing page, bottom left)* and the golden ratio *(facing page, bottom right)*. The golden spiral was especially helpful in that as the shadow was cropped out, the foreground seeds curved up and left leading the eye around the egg cup and into the space the right of the cup. The viewer's eye pauses here, and then is ushered forward with the spilled seeds to rest where it had first entered the bottom of the picture on the outer spiral.

These grids can be toggled on in the settings of many apps and also in Adobe PhotoShop computer software.

This final image *(above)* was taken with an iPhone XS Max and refined on the computer using Photoshop.

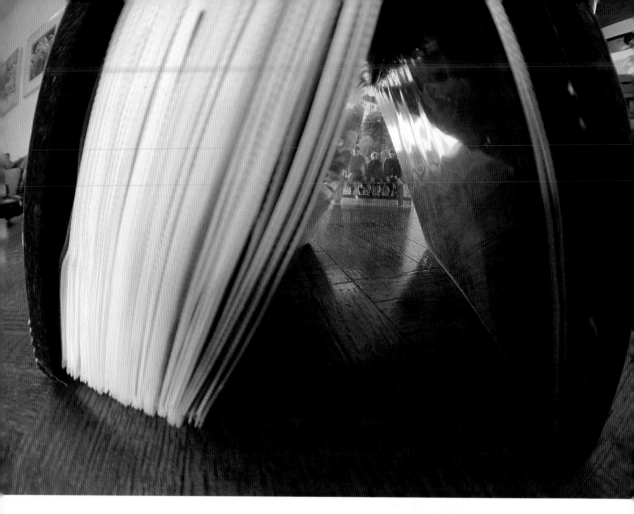

Curves and Leading Lines

Curves make the viewer linger on an image. Subtle curves, like leading lines, can direct the unwitting viewer through the image's picture plane— in, around, and back again. More perceptible curves build dynamics in an otherwise tranquil subject, in this case, a photo album and family portrait.

Both of these still lifes also have converging lines that draw the viewer's eyes deeper to an inner plane. We are used to experiencing perspective in this way. Converging lines is a useful way to bring the viewer's eye directly to your subjects. An interplay between curving and converging lines, when achieved, can be satisfying and intriguing to both the artist and the viewer.

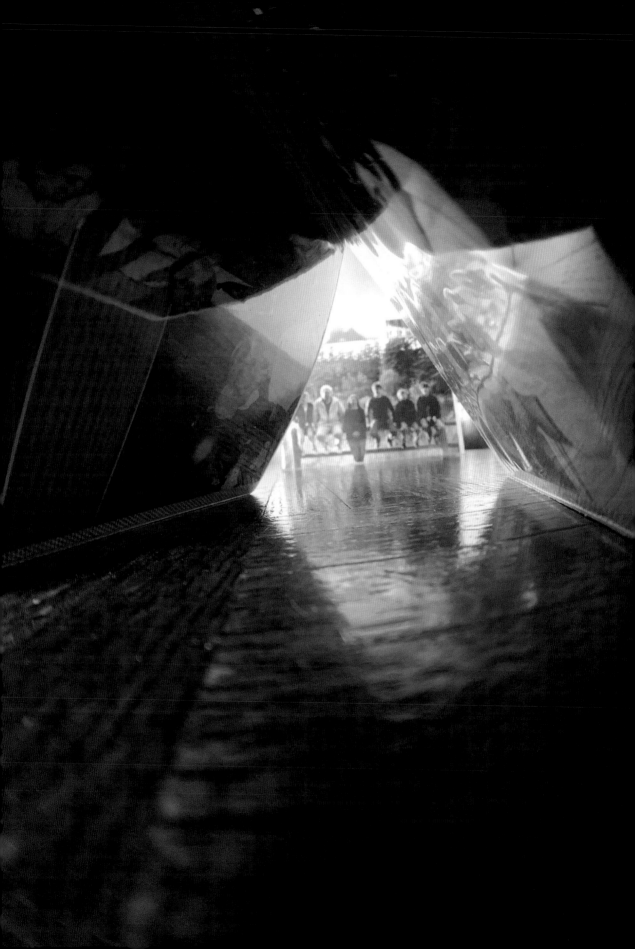

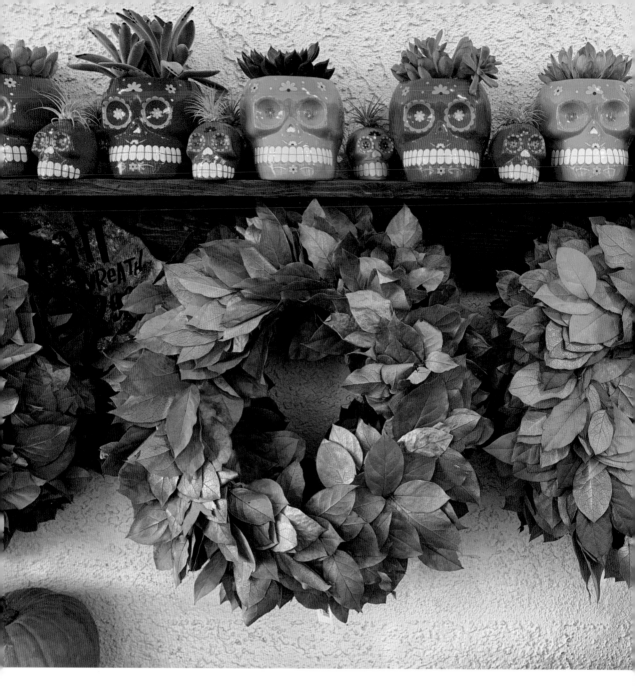

Repetition in Still Life

Repetition is the recurrence of an element. It can be an object, color, shape, or whatever, that occurs over again. Our minds want to connect occurrences, making lines, shapes, and planes with them. Repetition is also the basis for patterns. In the square still life above, the repeated

objects—the ceramic skulls and the wreaths—repeat horizontally across the image. Our brain interprets this as two horizontal lines.

Interest can be created by modifying the repetition and altering it in some way. For example the skulls vary in size and color. Repetition does not need to be of the object within the still life. It can be a design element that repeats, too. Although

This still life was photographed with the hair-styling objects laid on top of a light box, and illuminated with lights below.

"Interest can be created by modifying the repetition and altering it in some way."

different in size, the circular outlines of the multicolored small rubber bands *(below)* is similar to the larger rubber bands arranged diagonally. The singular larger blue elastic is obviously of different material, but its linear closed shape echoes the rubber bands circular element.

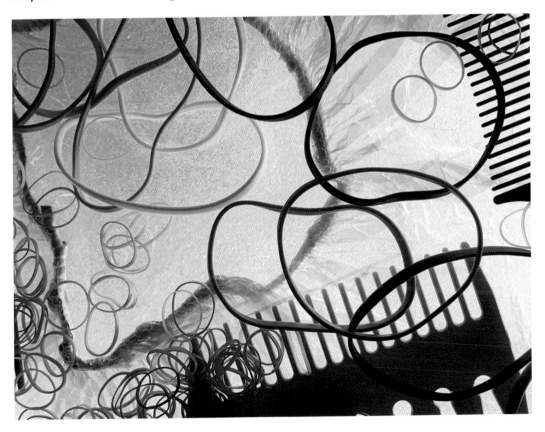

Patterns

Patterns have repeated components that become significant elements in a design. Patterns can become a

"The patterns fashion an air of the extraordinary into the most mundane everyday objects."

feature in still lifes in different ways. First, the texture used in the shading or painting can be a distinct pattern. For example, the still life of bottled soap and shampoo on the side of the bathtub *(bottom left)* has shading that is textured when produced with the app called Picas. Although this texture is fairly well defined, it is also somewhat irregular, making for a pleasing still life image.

Second, the pattern itself can be the subject of the work. This still life of a dime *(facing page)* is an example of a pattern that became more prominent than the object itself. The coin was photographed with a Moment macro lens fitted on my iPhone. The file was then opened in the app called Matter. In this app, an image can be integrated with three dimensional forms that reflect, reshape, and multiply parts of the image, and in this case created patterning. Some transformations will be more successful than others. However, all of options are intriguing. The patterns fashion an air of the extraordinary into the most mundane everyday objects.

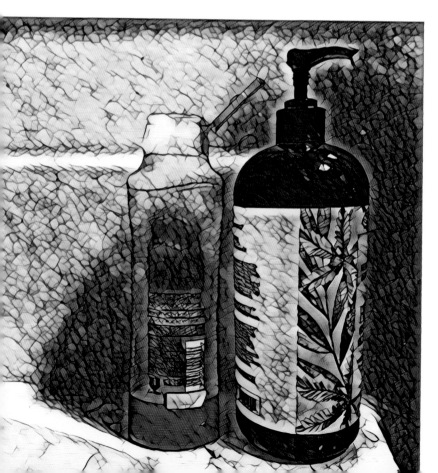

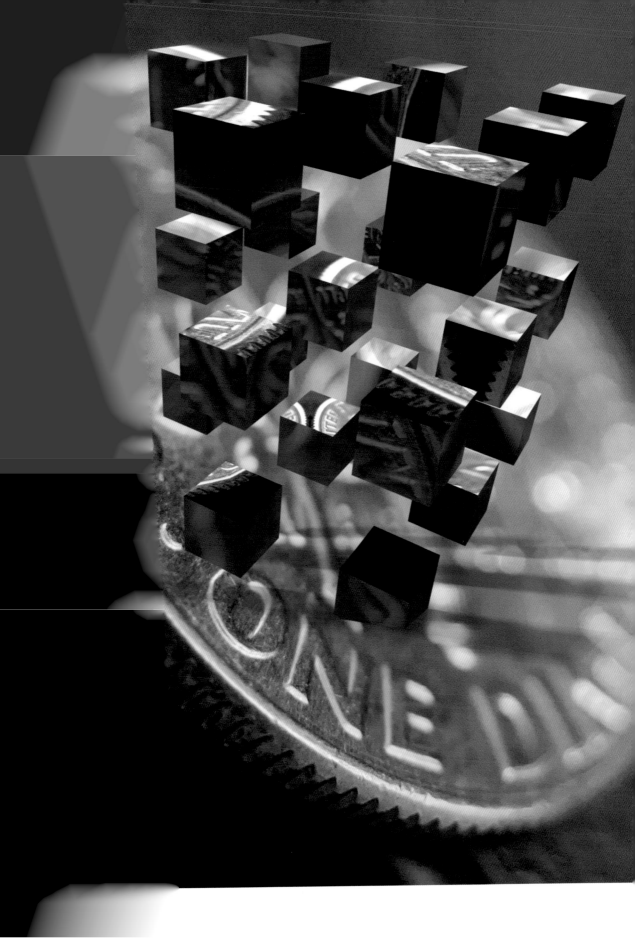

Symmetry

We find bilateral symmetry appealing in the faces of others, but it can also appear simplistic and boring in a still life image. A symmetrical object, like an egg can be placed off center to create tension or more interest. The egg has nearly perfect symmetry, so I saw no reason for meticulous symmetry in its placement. However, I felt differently in the fallen apple still life *(facing page)*. The left half of this photograph was mirrored to the right using an app called Kansulmager.

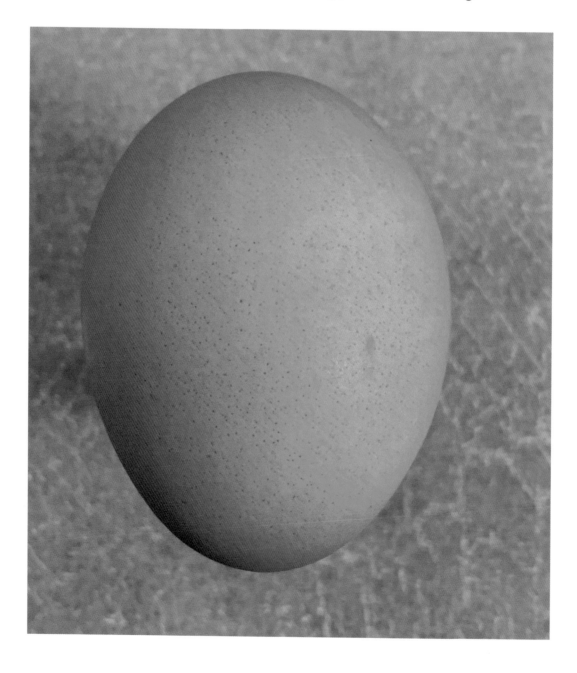

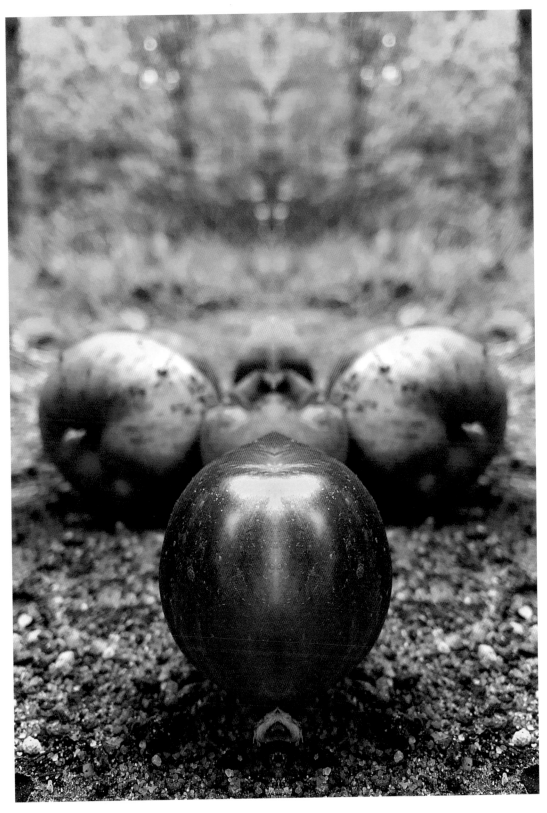

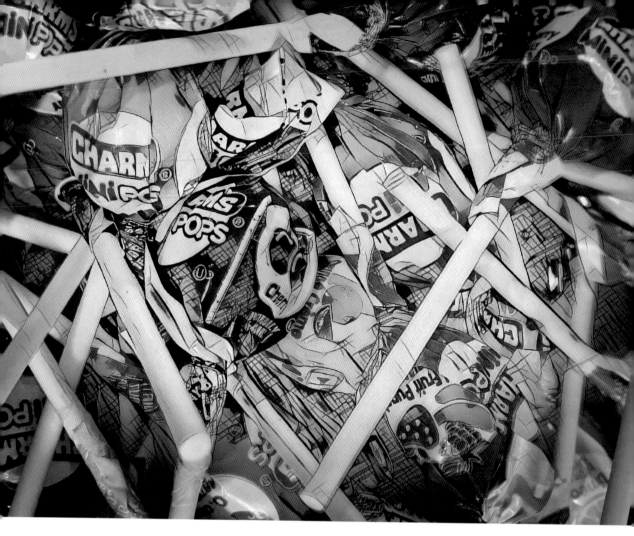

Color

Doing without color, for most of us, would be unimaginable. Fading the center of this still life of colorful suckers into a black & white cartoon was a fun test of skills using layers. Layers are not available in all apps. In the beginning the learning curve is a little steep, but worth the time. This still life was made in the Adobe Photoshop Mix app.

Texture

Texture is the quality of a surface. Objects have a surface characteristic that are three dimensional: smoothness, roughness, random or patterned, soft or hard. Once objects are photographed, the two-dimensional image of the texture is a perceived visual of the three-dimensional qualities. As an image maker, the photographer can influence the qualities and prominence of texture through lighting techniques. A larger, diffused light source will soften the texture. A more direct source will create harsher shadows in the textured surface.

Introducing a variety of textures can help differentiate the objects. An object with a distinctly different texture from the other included objects can create a story or questions in the viewer's mind. Or it can direct the viewer's eye. Also an unexpected texture can create novelty.

In the market basket still life, I again used the Adobe Photoshop Mix app for its use of layers to merge two different versions of the image, one realistic and one turned into a cartoon-like graphic. The stacked baskets are the focal point and were kept realistic. The rest of the image is the cartoon graphic, which was further subdued with a dark vignette applied in the Snapseed app.

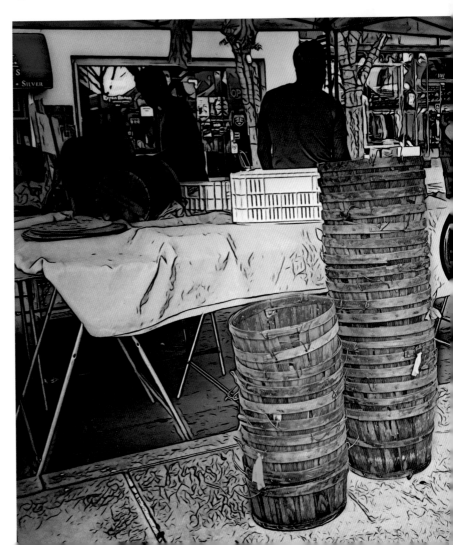

Selective Color

Selective color is when particular areas of your still life are in color

"Selective color can direct the eye to wherever you want the viewer's eye to go."

and other areas are in black & white or other limited color pallet. This technique can be used to spotlight parts of the image. Or you may want to contrast one area with another. This contrast might be between now and then, real and unreal, desired and undesired, important and insignificant, and so on. Selective color can direct the eye to wherever you want the viewer's eye to go.

There are many ways to render selective color. Some apps will easily manage separate colors, such as, Afterlight, PS Express (Pop Color), and Clip@Comic. For this photograph I selected purple, green, and yellow objects *(left),* but the photo is rather uninteresting. I wanted the soap duck to stand out. In Adobe's PS Express app, I selected Saturation, and then de-saturated seven of the colors, leaving only yellow.

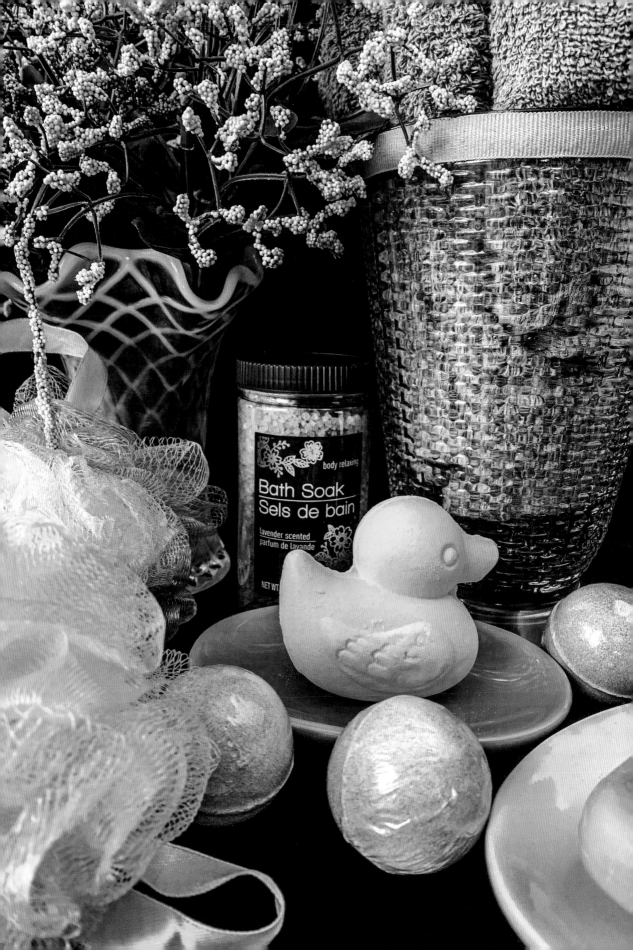

body relaxing

Bath Soak
Sels de bain

lavender scented
parfum de lavande

NET WT

Silhouette Still Lifes

A silhouette still life emphasizes the outlined shapes of the objects within it. It is black and white or any two colors without any in-between gradations. In art, silhouette portraits were produced with a bright light creating

"Good photographs to turn into silhouettes images are ones that are backlit."

a shadow likeness on paper before the advent of photography. Shadow puppetry has been used for centuries to tell silhouetted stories to large audiences. And the use of stencil on pottery has been used to create silhouette decorations. Silhouette images were easily reproduced on printed materials such as early newspapers and books, before the refinement of the more sophisticated photogravure process. Silhouette imagery is part of our visual lexicon. So, there is an appeal to use silhouettes in still lifes.

Good photographs to turn into silhouette images are ones that are backlit. On this photo, the sunlight was spilling in through the window from the outside *(facing page)*. It was mid-morning, and the angle of light was fairly low. As a result, the silhouetting effect of the light accentuated the shapes and outlines of the objects, especially on the bouquet and music book. The Snapseed app was used to turn my photograph into a silhouette. On opening my photograph in Snapseed, I glanced through Looks instead of Tools. This gave me twelve presets, and I chose the Silhouette preset.

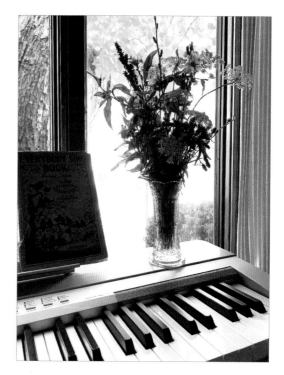

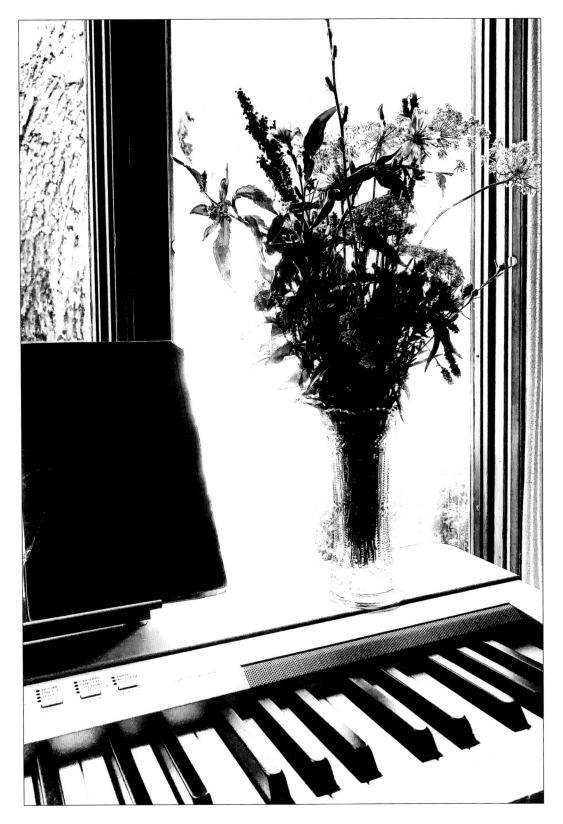

4 Still Life Lighting

Light makes seeing possible, and it's the central element of still life photography.

The camera sensors in the smartphone react to light. Then, the programing in the native camera app, or any third party apps, do their magic. Variations seem limitless. Third-party camera apps, such as Camera+2, Moment, and ProCamera, give amazing control over lighting situations, much like a SLR camera.

Experimenting with natural, artificial, and do-it-yourself lighting is contagious, and it can produce surprising results.

Sunlight

Sunlight can be harsh, creating extreme highlights and producing unforgiving shadows. Nevertheless as you experiment, you will notice sunlight changes in each environment, time of day, and weather. Open light can be found under trees or building overhangs. Long shadows can be made in strong morning or late day. Overcast days are great for more diffused light with less shadow development.

Direct afternoon sunlight made this handful of beach glass churned by the ocean *(facing page)* look like sparkling gems. The shadows, most often present in direct sunlight, were minimal in this photo because the sun was directly overhead, and the tiny pieces of glass cast tiny shadows directly beneath. I found that the sand beneath the glass reflected light upward so the glass was illuminated from all directions, and any shadows were minimized. The minimal shadows and contrasting color of the beach sand helped create a feeling of depth as the glass sat on top of the sand in this still life photo treated in the Waterlogue app.

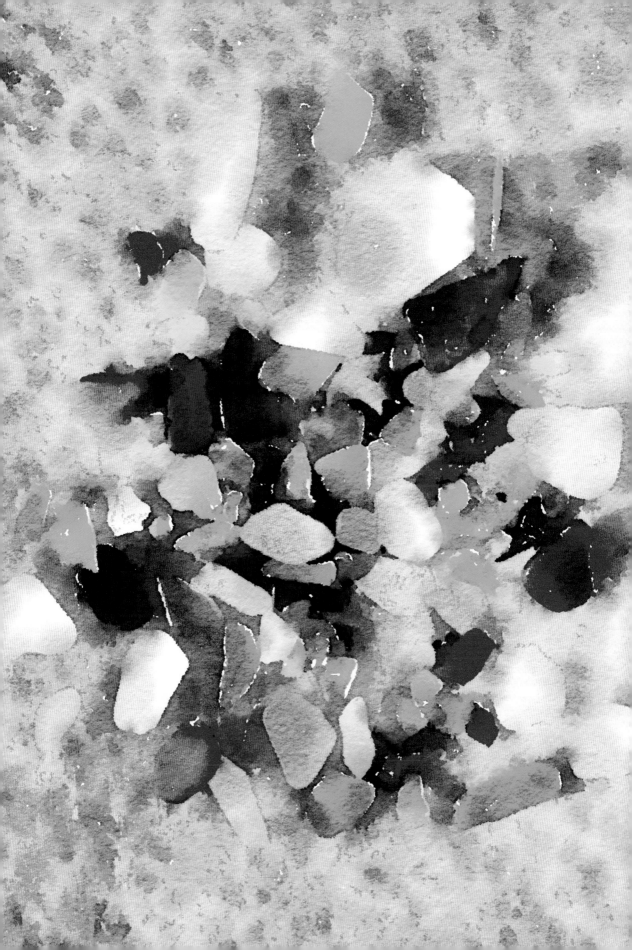

Diffused Light

Diffused light is ideal for still life photography. The light is best from a strong light source since the diffusing material will reduce the amount of light, whether it is a curtain, glass, or anything else that will scatter the light in many directions.

In this image *(facing page),* the diffused light is filtered through a translucent curtain scattering its rays.

Diffused, it illuminated the delicate details on the glassware. Diffused light is softer than direct light. Notice, even though the photograph has been processed into a drawing using the Pic Sketch app, there is no evidence of strong shadows. The objects in the still life are evenly lit throughout without any area getting washed out. As a result, details of surface textures on the table, bowl, stem wear, table covering, and window curtain are aptly recorded. What makes this still life interesting is the many patterns produced by the surface textures. The patterned textures define the objects' shapes, as well as the degree of their transparency and translucency.

In the original photo *(left),* the diffused, low-angled evening light mutes the purple, blue, yellow, and pink colors. It was the textures and translucent tracing that I was interested in showcasing. And so, I chose to de-saturate the image.

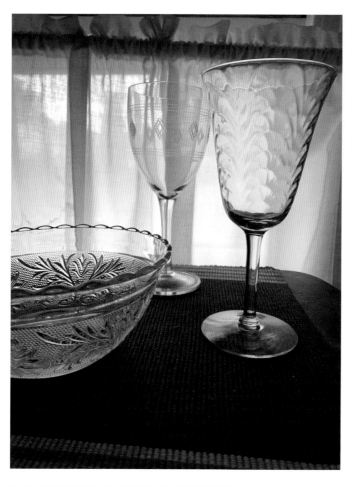

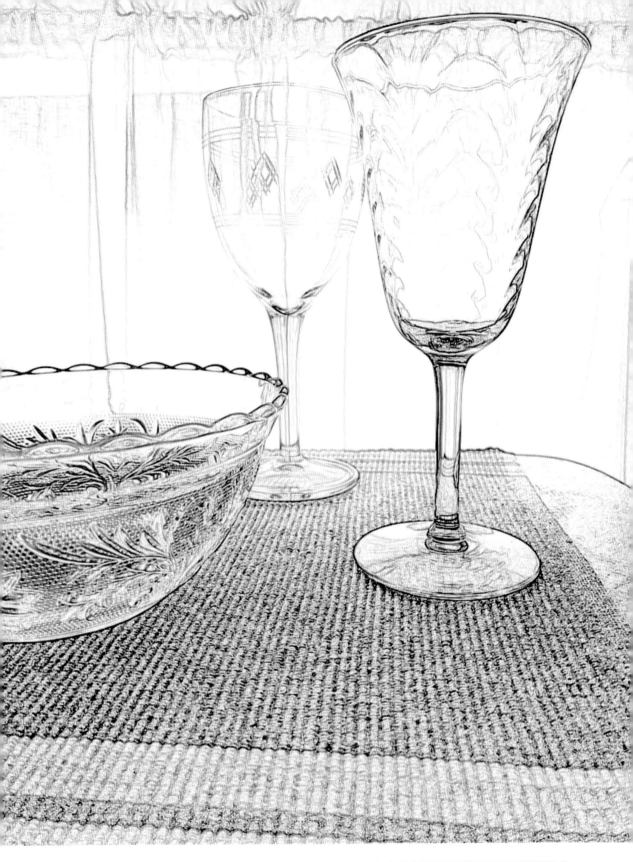

Window Light

A window area is a great place to set up a still life arrangement. A roof overhang usually helps to shade and diffuse the sunlight from harsh or intense, direct sunlight.

This image of a rare antique bird collection *(facing page)* was taken when viewing it at a university in one of its original buildings. The building had tall and expansive vintage windows *(below)*. The sun's rays were not aimed directly into the building, but were strong enough to create silhouettes against the panes. There was plenty of sunlight to create soft shadows on the surface beneath the birds.

Collections provide interesting still lifes because we are intrigued by similarities and differences of their components. In having many pieces placed together in an image, the lighting will spill over them, giving the viewer an idea of the collections' home environment. When ambiance is expressed like this, with the help of lighting, an understated still life story can emerge.

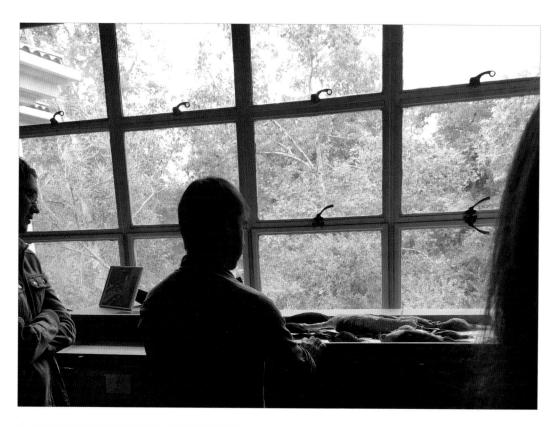

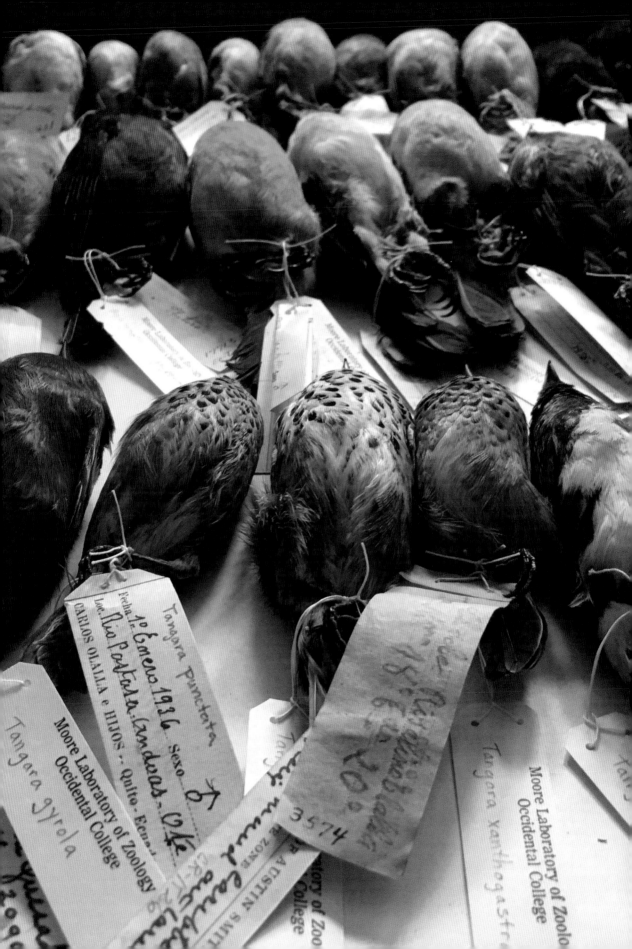

Adding Light with an App

The original photo *(bottom right)* was taken in diffused window light, coming from far left and far right. There is no direct sunlight in the scene.

After applying a texturing filter, the image was opened in the Light Ray 2 app *(top right),* where different light beams can be selected. Position, hue, scale, brightness,

> *"Position, hue, scale, brightness, blur, and displacement of the light beams can be altered."*

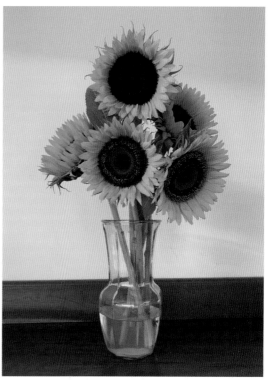

blur,and displacement of the light beams can be altered. In the final image *(facing page)* a fairly high, strong light beam was applied creating distance between the flowers and the background, while also making the background lighter and more prominent in the image. The Rays, another app, also offers similar light effects.

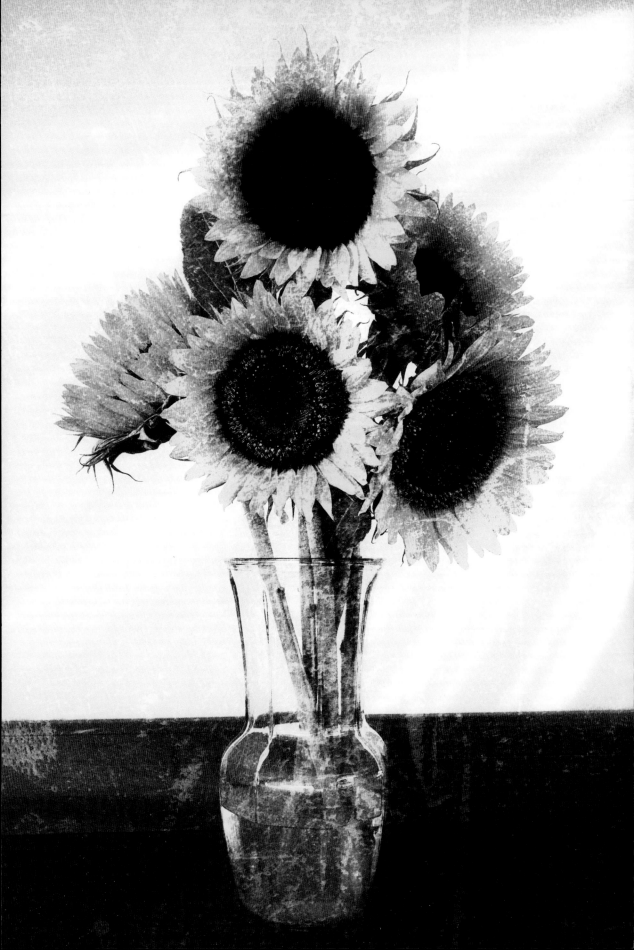

DIY Light Box Back Lighting

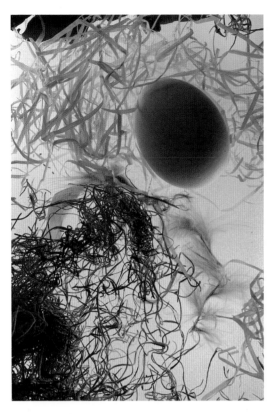

A light box can provide interesting lighting for objects that are textured and have degrees of translucency— that is, varying amounts of light coming through the object. The light box I used was a DIY (do-it-your-self): a 14x18-inch piece of sanded glass, propped up on the corners with books, and elevated just high enough to put two LED flood lights underneath. LED lights are cool, versatile, and economical.

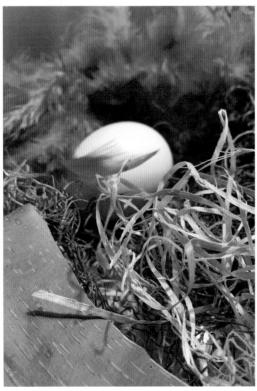

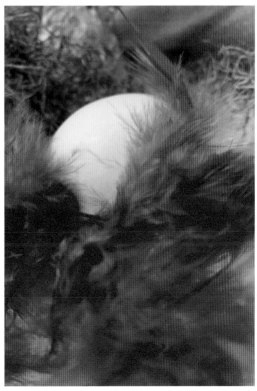

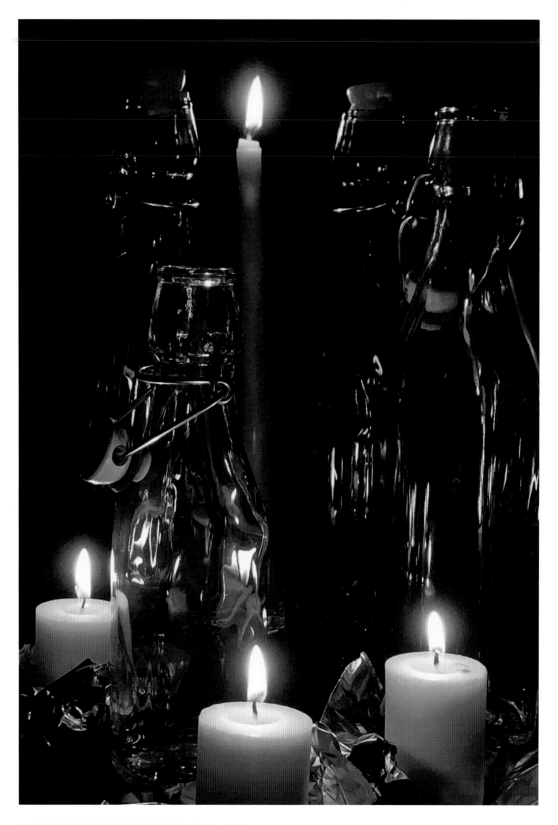

Candlelight

Candlelight creates atmosphere in a way that no other lighting can. The ambience of candlelight can set a multitude of tones in a still life. This lighting suggests warmth, elegance, homespun coziness, spirituality, or sophistication.

The iPhone I used does a good job in low light settings. Whichever smartphone is used, this is an ideal

"The greatest amount of illumination is nearest to the flames. . ."

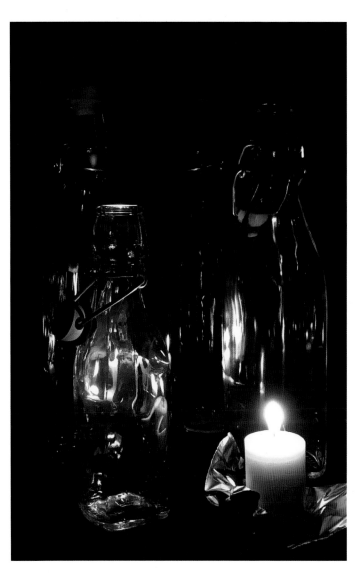

situation to use a tripod, ensuring a sharper image. As can be seen in this image *(facing page),* the greatest amount of illumination is nearest to the flames, and this is where you will get the greatest amount to detail in your objects. Include more candlelight in your still life, especially near the areas where attention and detail is preferred. Areas away from the flames will recede into the darkness and background *(left).* Use the candlelight to determine the tone of your still life and to direct the viewer's eye to what you want them to see.

Reflections
Casting Images

Reflections are everywhere. We live in a world of manufactured surfaces that reflect the images made from light. Some cast these images most accurately like mirrors *(right)*. Others, with concave or convex surfaces, distort their reflections. Other surfaces reflect in an unpredictable manner. Still others have surfaces that are dynamic and ever changing, such as puddles, rotating apparatus, or objects blowing in the wind.

The subject becomes complex in a still life with reflections. Is the subject the object that is doing the reflecting, or is it the object reflected. Or, is there a balanced tension between the two where they coexist and have become part of the same story? There is an interplay in the viewer's mind when looking at an image with reflections. The viewer perceives the objects, identifies them, places, and relates them to each other. Then, perceives again, to survey if everything makes sense.

Images with reflections are fun to make, and they are fun to see.

"The subjects becomes complex in a still life with reflections."

Reflections can make a story or statement have more impact. Mirror effects can be real, or you can use an app to create one. The Spoon-on-Book still life *(facing page)* reverses the text in the convex surface of the metal spoon.

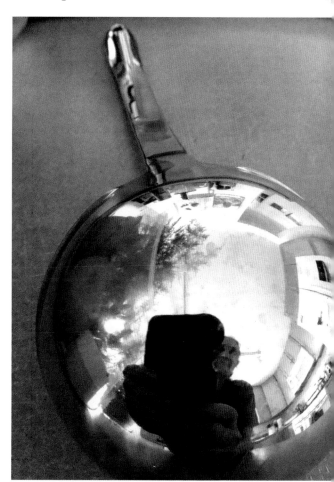

5 The Power of Apps

App with adjustments, filters, presets, and more can transform your still life photo.

The artist can use any media to make a still life. Before photography, the masters used media such as oils, tempera, and acrylic paints or charcoal, pencil, and pastels. Print media was also popular. Smartphone cameras produce still life photographs, but their apps can make still lifes that resemble other kinds of media in very exciting ways. The adjustments, filters, and presets allow for control and infinite variations. The apps can easily make still lifes that are reminiscent of non-digital media.

Kinds of Apps

There are three basic kinds of apps aside from the camera app. First are apps that offer a variety of presets. This may sound limited, but some offer amazing results. Second, there are apps for basic adjustments such as Snapseed, Adobe Photoshop, Adobe Lightroom, VSCO, MOLDIV, Darkroom, Pixlr, and many more. Third, there are more full-featured apps that can offer basic adjustments, presets and more complex functions like layers and masking.

Apps with Filters, Layers, and Effects

Many apps have filters that can be applied to your still life such as Grunge, Grain, or Glow. Other effects are lens blur, vignettes, frames, and so on. And of course, more than one or two can be used. It is up to you and your imagination. Smartphone apps can create unlimited variations of your initial still life photograph. Knowing which one you keep as the final still life is a challenge.

This Hollywood still life *(facing page)* was a photo taken from a hodgepodge of trash on the curb from—old strips of movie film, animation models, a scarfed bust, and special effect gadgets, topped with an old mattress. I used a posterizing effect.

This still life of stylish mannequins standing in a row *(right)* was taken in bright sunlight. I like how they stood out against the stucco building on top, and are framed by their shadow in the lower right. I added a layer of grain in Snapseed to soften the harshness of the midday sun.

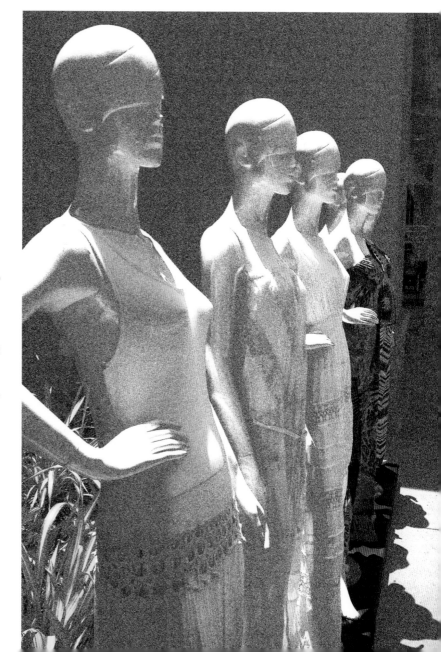

*Phone apps,
such as
Visionary
used here,
create infinite
variations.*

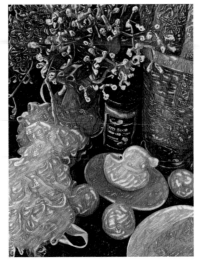
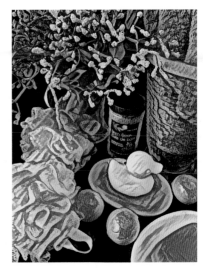

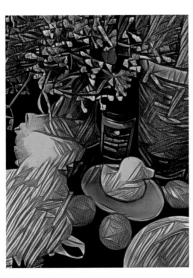

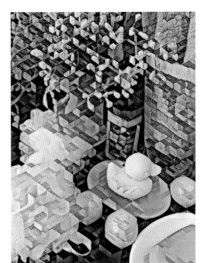

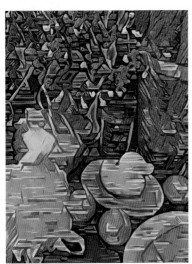
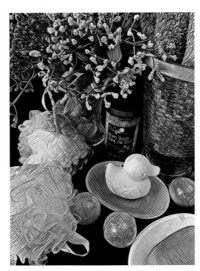

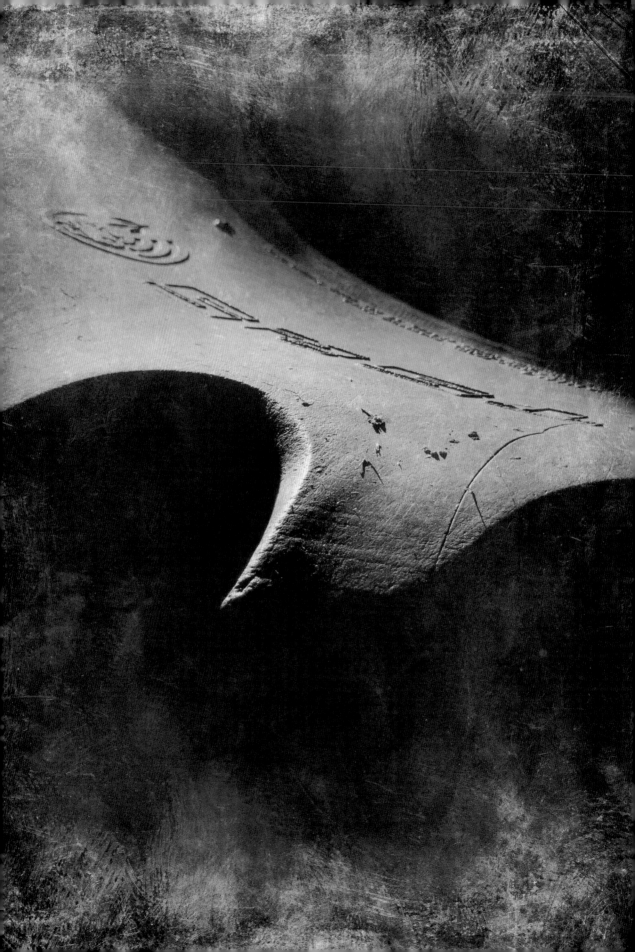

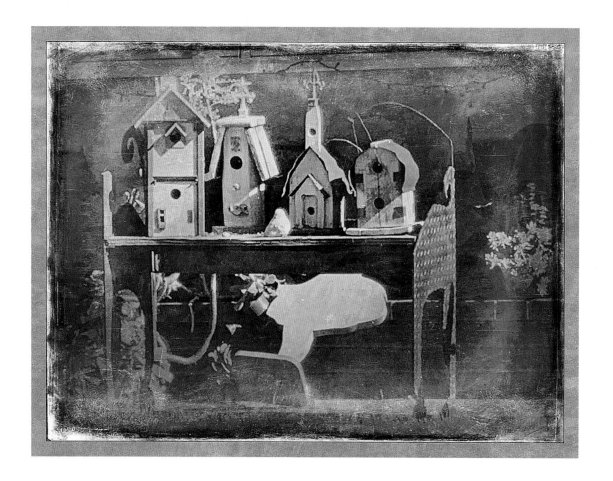

App Formulas

Many apps offer formulas. They are like a set of recipes or presets that

The app used for these two still lifes is appropriately called Formulas. I have the initial set of formulas that comes with the app. But, I understand artists can contribute new formulas through social media. This collection of formulas makes images look as if they come from an old photo album instead of recently taken. It turned my newly made images of relatively new objects into antique-looking still lifes.

can be chosen. You choose one, and it has a set of things it does. For example, apply a degree of sepia, a layer of a particular texture—like dust, and a particular kind of vignette.

Many apps have presets as their only offering. Other apps may have a degree of control to attenuate one or two of its variables. You may find these kinds of apps to be very narrow and simple functioning, but the effects may be just what you need, and worth having on your phone.

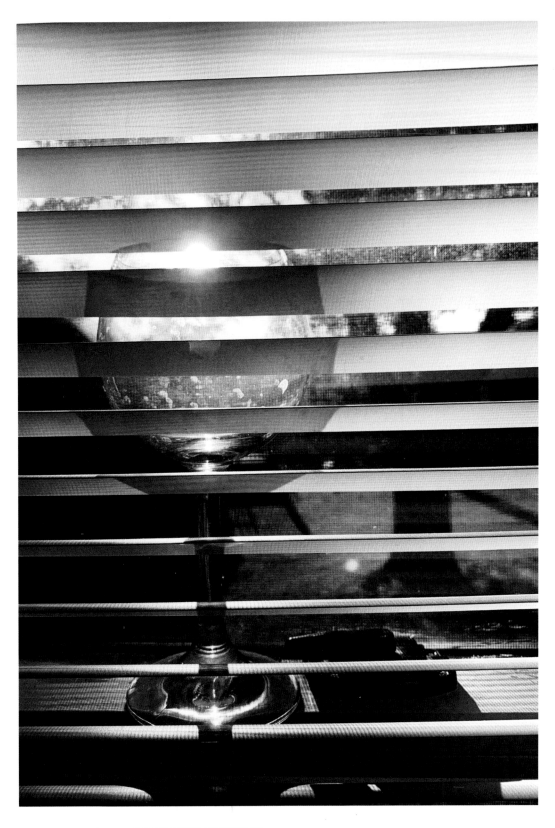

Black & White Still Life Images

Black & white images can be very powerful. Color images can be transformed using brightness, contrast, and grain using the Noir selection in the Snapseed app *(top right)*. However, it was first treated with a Glow filter *(bottom right)*. Other apps, for example Photo Shop Express, offers a multitude of controls for turning a color image to black & white: exposure, contrast, highlights, whites, blacks, temperature, tint, vibrance, saturation, clarity, fade, grain, sharpen, and reduce luminance. A quick and easy app for black & white is Noir. Also, don't forget that many smartphone cameras have a selection for black & white images. Still life photos taken in black & white with the iPhone camera can always be reversed back to color in its native photo editor.

Mono-Chromatic Apps for Still Lifes

Images can also be transformed to a silhouette or to a two-tone image of black and white or any other two colors. An image converted to black & white can be toned with color such as sepia, blue, green, warm gray, or whatever is desired. When the original image *(top right)* is converted to two-tones *(facing page)*, there is usually no gradations because the colors can't provide a normal range of tones. Many smartphone apps can turn your still lifes into mono-chromatic images: Snap-seed, Pic Sketch, Inkwork, MySketch, Popsicle, and many more.

Vignettes

A vignette effect surrounds a still life subject as it gradually fades, darkens, lightens, or softens its focus into the background. It can be abrupt or subtle. Vignettes have the power of concentrating the viewer's attention in one place within the still life—usually where the subject is located, reducing or eliminating the likelihood of the observer being detained with extraneous details. Observe, in these examples, the different kinds of vignettes and the affect they can have on the final image.

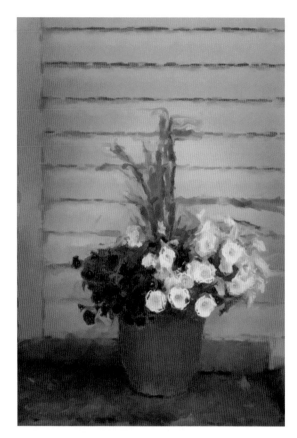

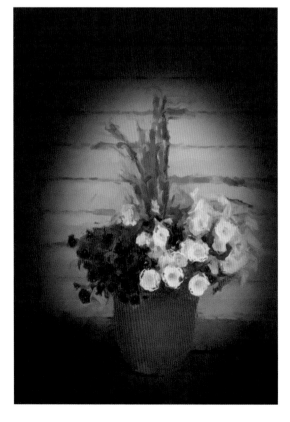

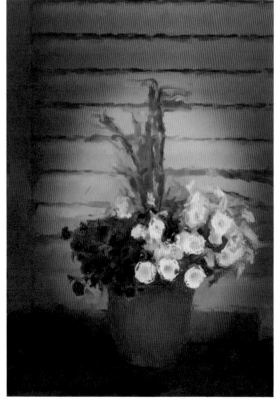

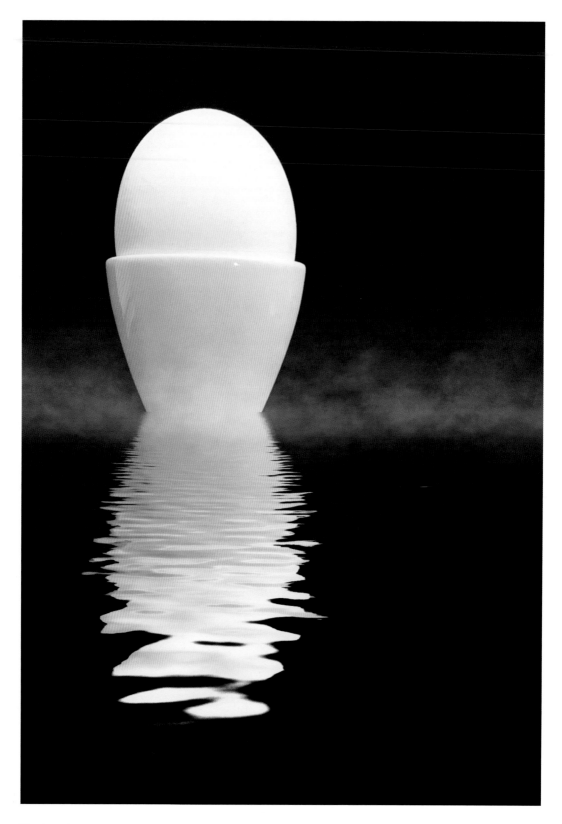

Make Reflections Using an App

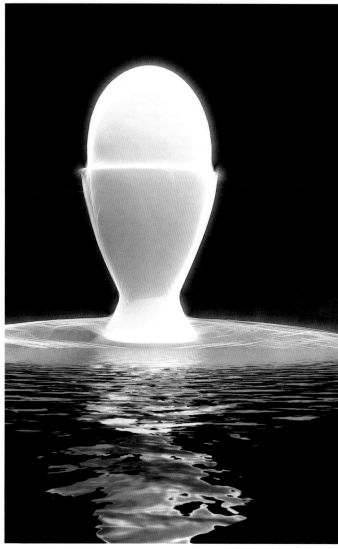

The original photo *(top left)* of the egg seated in an egg cup, standing on an inverted antique wooden bowl, was taken against a black background with the iPhone on a tripod. Basic adjustments were made in Snapseed to make the shadows on the left side of the egg and egg cup more pronounced. The file was then imported into the app called Reflect. The line of symmetry, where the reflection occurs can be adjusted, as well as waves, blur, and fade *(top center)*. A fog can also be applied *(top right),* which helps to obscure the line of reflection. Variations *(right)* are infinite and impressive.

Art Effects

The Deep Art Effects app does just that, simulate a multitude of artistic techniques. The app lets you choose from a range of artistic effects. Then you can use a slider to determine how much of the effect to apply to the photograph. These images are an example of the variety of styles and effects that can be worked, and there are many more. The file output for app is fairly small, but can

be up sized using an apps such as Handy Photo. There are many other apps that offer a similar range of art effects, such as: BeCasso, ArtCard, Picas, and Visionist.

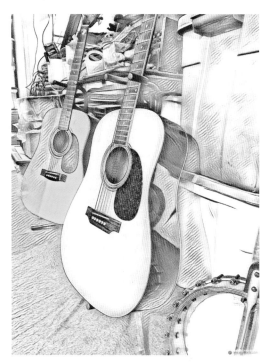

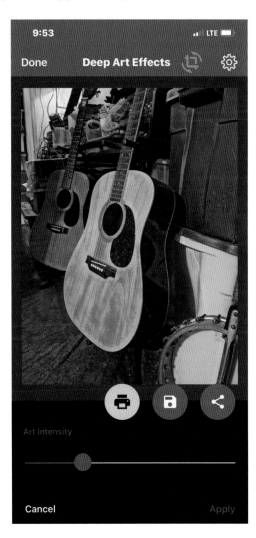

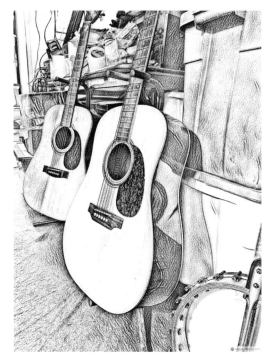

Textured Layers

Many apps have the ability to apply texture layers. Distressed FX is an app that has in-app textures that can be applied in two separate layers. It also allows access to the camera's photos to be applied as textures. Many other apps can be used in this manner as well. Any app that uses multiple layers can be used to apply textures from your own smartphone photo collection. Use your own textures. Whenever I see an interesting texture, I photograph it and put it in a separate album called "textures" for easy access.

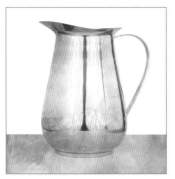

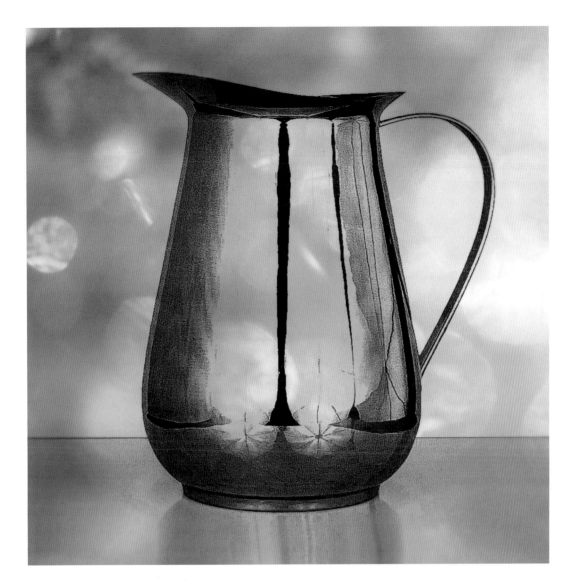

Layer Mode

Whether using an app that is focused on applying textures or a more universal editing app such as Snapseed, the texture layer can be applied in various modes, such as multiply, Overlay, Hard Light, and so on. Each mode creates a different variation. The strength with which a mode is applied to a layer can effect the final look of an image. The degree of a layer's opacity can often be adjusted, producing astounding results. Experimentation is key to getting the image you ultimately want.

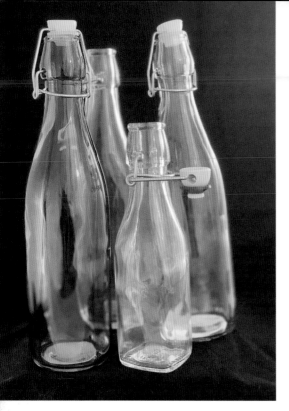

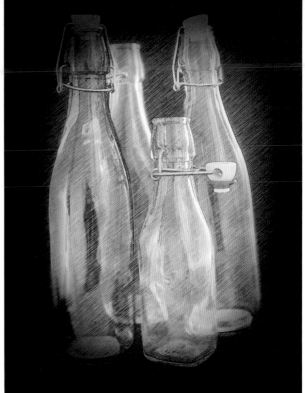

Artful-Graffiti Expression in a Still Life

The initial still life photo *(top left)* was of a variety of bottles shot against a black backdrop. The file was imported into Visionist app. A sketch effect was applied *(bottom left),* and then a vignette applied *(bottom middle).* The resulting image is top right. Lastly, a stone wall texture *(bottom right)* was applied giving the final still life *(facing page)* a painted art-wall look, or perhaps an artful graffiti expression.

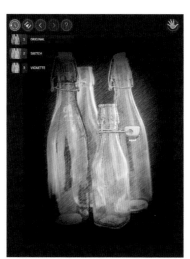

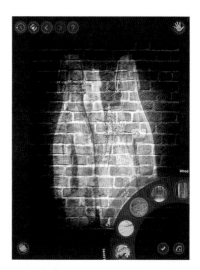

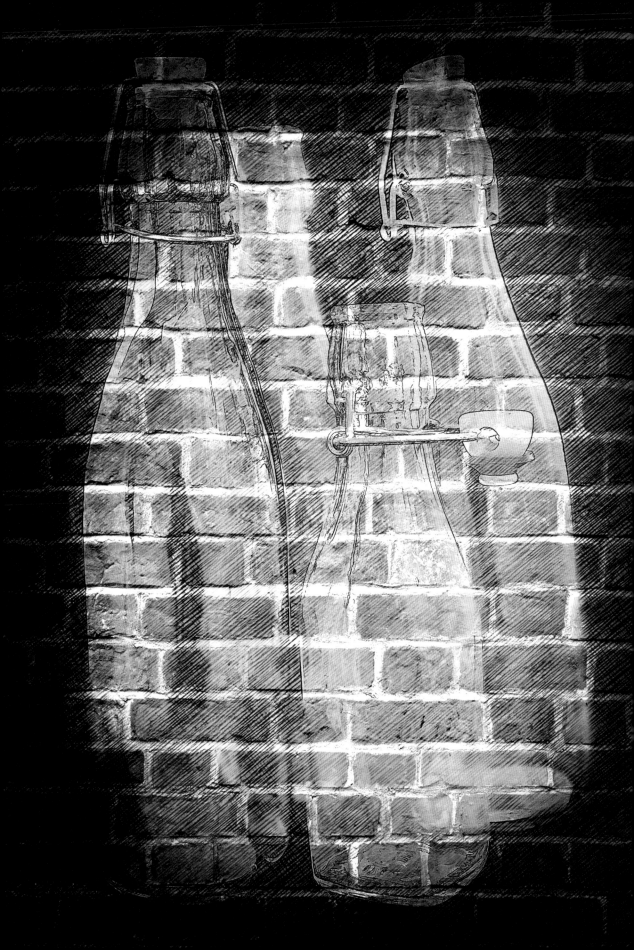

Photo to Still Life Drawing 1

The original photo *(top right)* was imported into the app called Inkwork. The app has numerous presets. Three other variables are line size, the ink and paper color, and cropping. Inkwork is a very simple, straight forward app that gives you quick success.

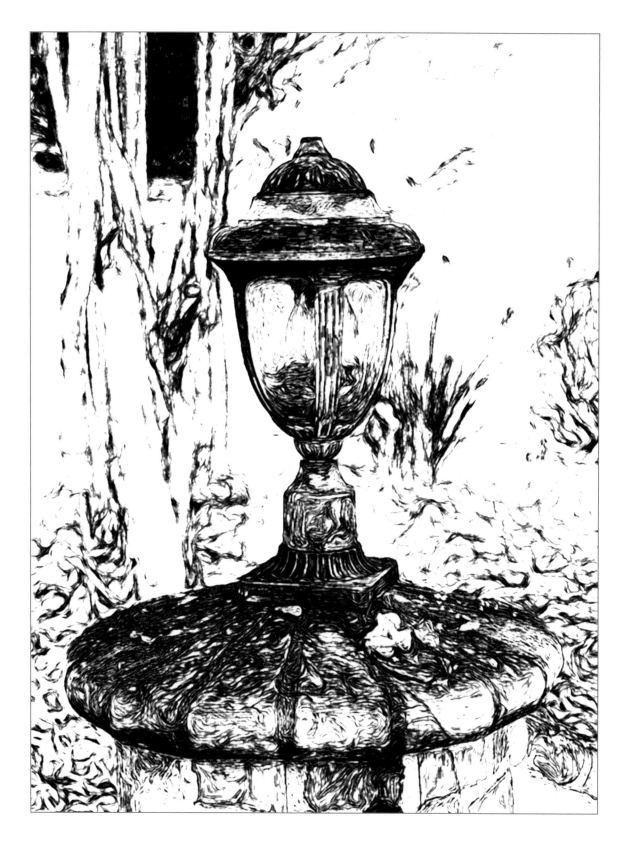

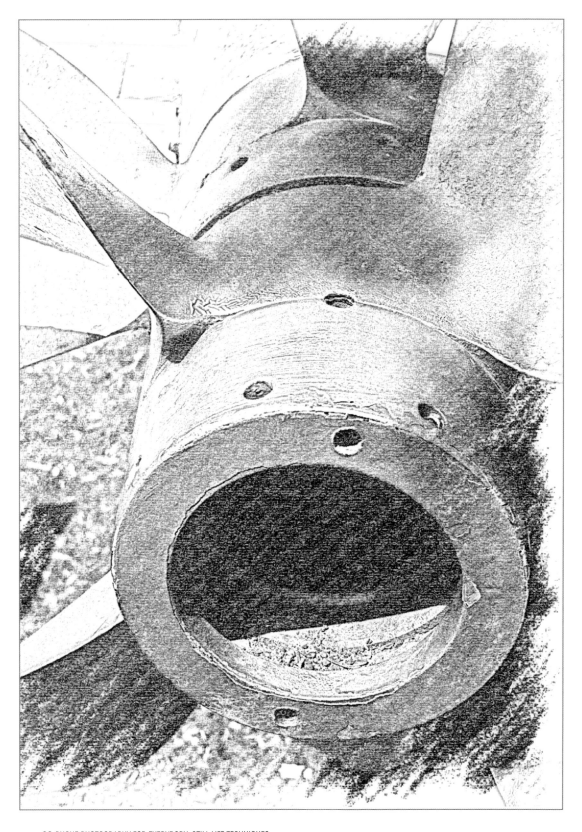

Photo to Still Life Drawing 2

The app used for this image is called My Sketch. This photograph of a ship's propeller was taken in a Great Lakes naval park. A drawing, even one made from a photograph, can often show more about an object than the photograph. The details of a still life object can be emphasized, or understated, by selecting different options in the app *(top left)*. The elements of brightness and contrast can also be applied to any one of these options. Notice in this drawing *(facing page)* some of the details appear more prominent than in the original photograph *(bottom right)*.

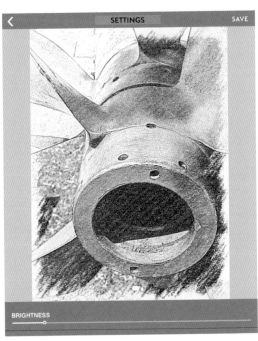

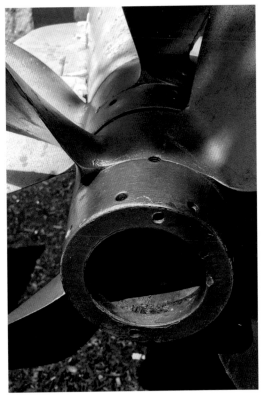

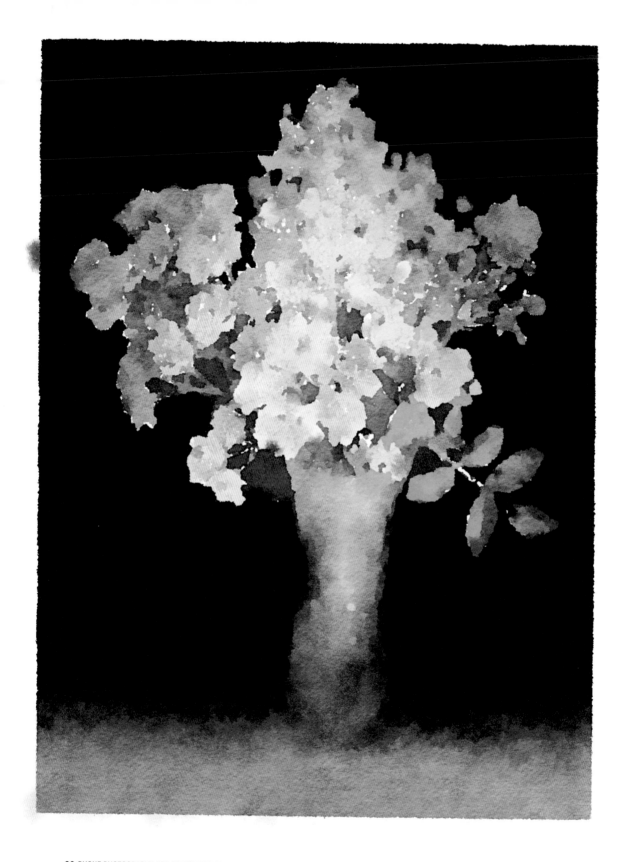

Photo to Watercolor Still Life

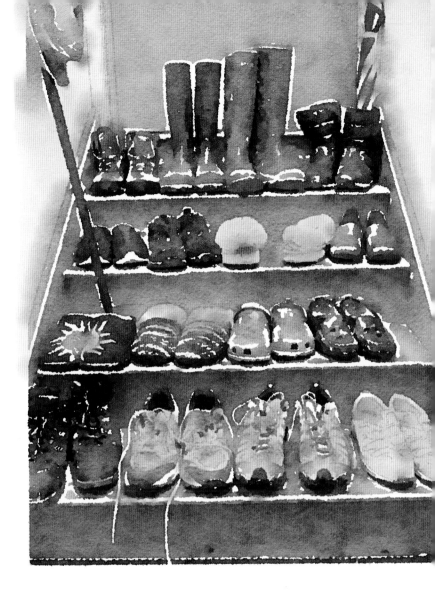

Watercolor paintings show degrees of transparency. They are full of light. They can even show luminosity of a still life subject in near darkness. Watercolor painting, with all the necessary control needed, is a medium that has an unrestrained and spontaneous quality. Can an app turn a photo into a watercolor-like painting?

The app Waterlogue comes close to actual watercolor painting. It is a simple app with twelve different choices of image transformations, five sizes, six choices of dark-to-lightness, and border/no-border. Details are limited. Both these still lifes were made in Waterlogue. If you wanted to supplement Waterlogue images to create more preci-sion, there's no reason you can't import the file into other apps. Details could be added by importing the finished watercolor still life into a painting apps such as Procreate, Sketches Pro, or Inspire Pro. The app Zen Brush 2, which also allows file import, has wonderful brushes that simulate a variety of watercolor brushes, ideal for adding more detail.

Still Life Oil Painting

Apps like Oilist, Adobes PaintCan, and iC Painter can simulate oil painting. A variety of brush strokes, some with degrees of transparency, are a great help in making your still life have a successful, oil-paint character.

First, start with an interesting and first-rate image. That being said, don't worry if it isn't either of those. The important thing is to import a photo and begin. Using Paint-Can is very tactile—as if you are using your finger or stylist as a paintbrush to transform your photo into an oil painting. Save, but don't settle and quit with your first attempt. Try to gain some control instead of using the app's automation. If you are not satisfied, export the image, and then import it into a different app where adjustments in contrast, brightness, and color can be made.

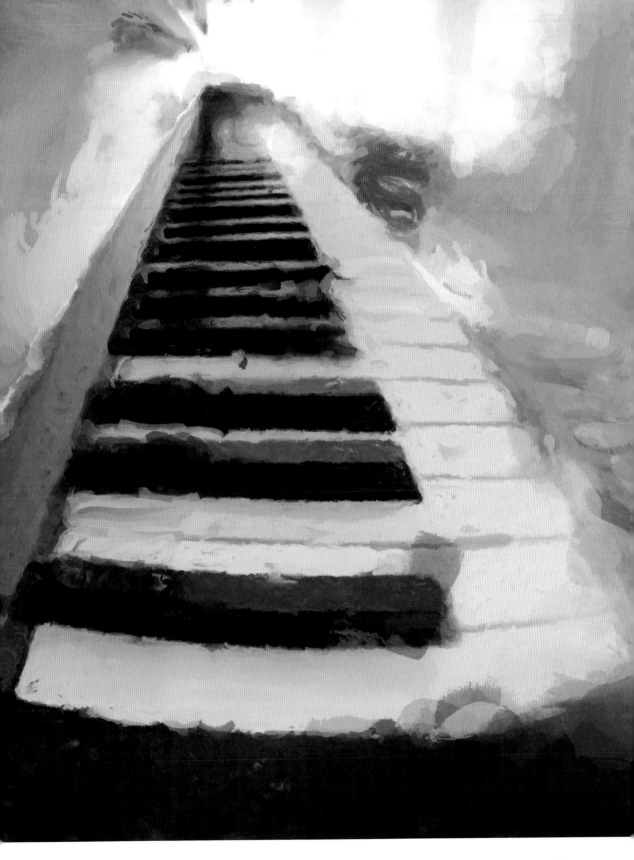

6 Masters, Movements, and Visual Styles

Still Lifes can use cultural and historic artistic contributions.

Master artists and art movements are part of our cultural and artistic vocabulary. Their great artistic innovations transformed the art of their day. Contemporary artists can choose to work their still lifes using the framework of any of the great historical art movements, such as impressionism or expressionist. And, they can challenge themselves to work in the style of a particular artists, such as Renoir, Picasso, Van Gogh, Rembrandt, and more.

Impressionism

If we characterized impressionism, it would be an emphasis on small and visible brush strokes, ordinary subjects—like still life subjects, and on representing movement and light.

This still life *(facing page)* began with the photograph *(below)*, which was of a bicycle with flat tires set up as a planter for flowers. It was taken at noon with plenty of diffused light, and it projected a nice sense of depth. It was imported into Adobe's PaintCan. The app doesn't give a great control of details, but it is simple and satisfying to use.

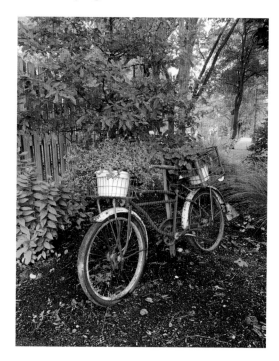

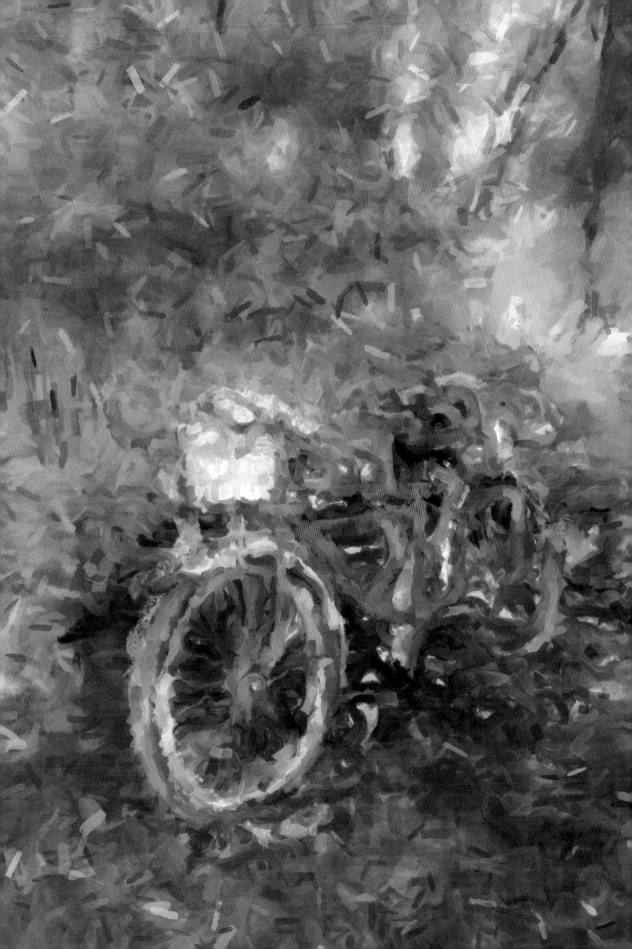

Pop Art

Digital Art

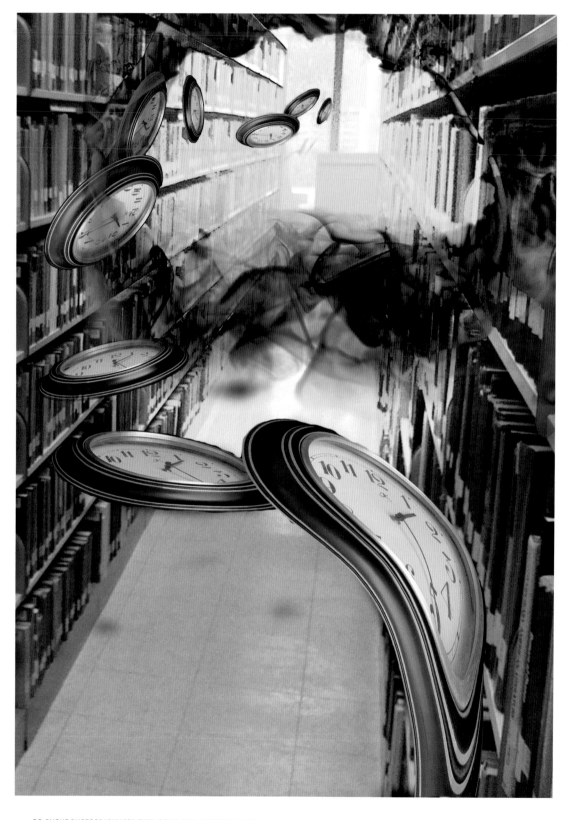

Surrealism

Surrealistic still life images combine the realism of photography with a dreamlike quality. Surrealism uses everyday objects to express the connection of the real and the dream—the conscious and the subconscious.

Salvador Dalí's painting The Persistence of Memory, is a still life/landscape of melting clocks. This and many of his other works also have anthropomorphic forms. Inanimate objects seem to be alive. I have always wanted to try and make a melting clock still life—Dali-esque.

Making this image *(facing page)* was complex. I took one photograph of a clock using my iPhone. It was imported into Photoshop on the iPad. The clock layer was duplicated nine times. The size, angle, and position of the clock on each layer was manipulated *(bottom left)* to give the feeling of it flying through the air. Several different backgrounds were tried; the library stacks—which is a public domain image I found—looked best, especially after applying a circular gradient to the upper middle area. The gradient used a Divide blend mode. The portal was made by positioning a fire ring image, and then applying the Different blend mode to its layer.

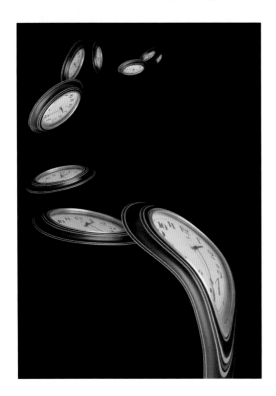

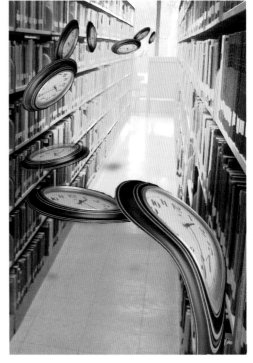

Layered Realism

This is an unaltered image of laundry tumbling in motion inside a laundromat dryer. Besides the tumbling clothes and the outside of dryer, the still life also shows the inside and outside of the laundromat reflected in the dryer window. The viewer needs to look twice to tease apart the multiple layers of what is real and up close, real and in motion, and what is reflected.

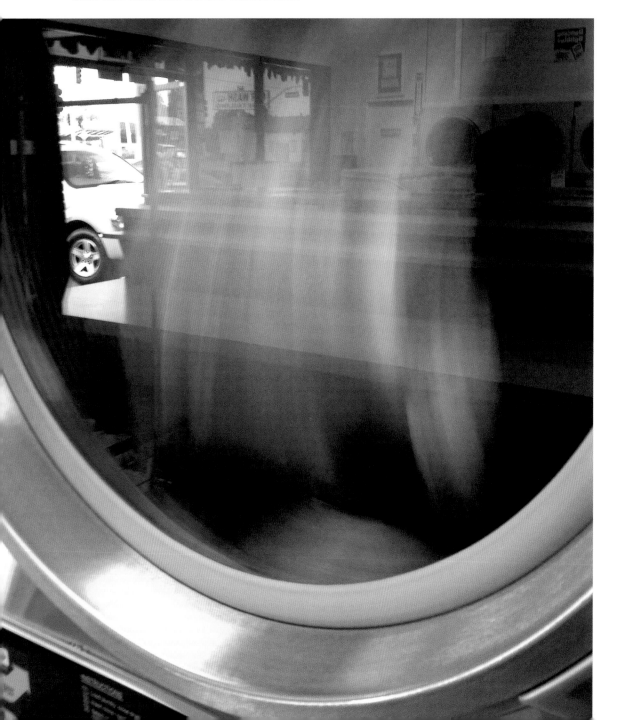

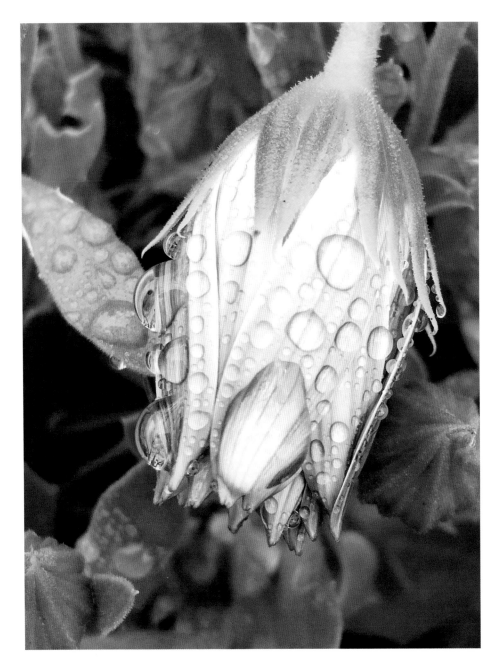

Super Realism

This still life, a flower in a recently watered potted plant, was taken with a macro lens attached to the iPhone.

The droplets seem to magnify the petal's details. It appears as super realism because it's details are ultra close. The droplets were caught before gravity pulled them into motion.

Abstract Realism

What is real and what is not in this still life? This environmental still life provokes the viewer because of its strong abstractions. The texture of the in-ground pool coping shouts

"The eye lingers to make sense of the complex components that cause an interplay between the tangible and the abstract."

real, and it is. It is the most concrete part of the image, figuratively and literally. The depiction of the water,

the bottom of the pool, and reflection of the building above, wrangle with each other to establish each of their own realness. Each of the qualities of depth, reflection, translucency, and texture confuse, as well as entertain the viewer's eye. The image becomes non representational—abstract. The eye lingers to make sense of these complex components that cause an interplay between the tangible and the conceptual.

Reflections, transparencies, inversions, strong spacial elements, patterns, and distortions can create abstractions because their visual strength dominates over the recognizable. The viewer's sense of reality is displaced, as their sense of what is real is challenged.

These iPhone images were not manipulated except for tweaking color, contrast, and typical sharpening. The abstract and the realism qualities are each strong. The image of the wine glass on a window sill, behind a slotted shade, was turned to black & white, emphasizing abstract qualities.

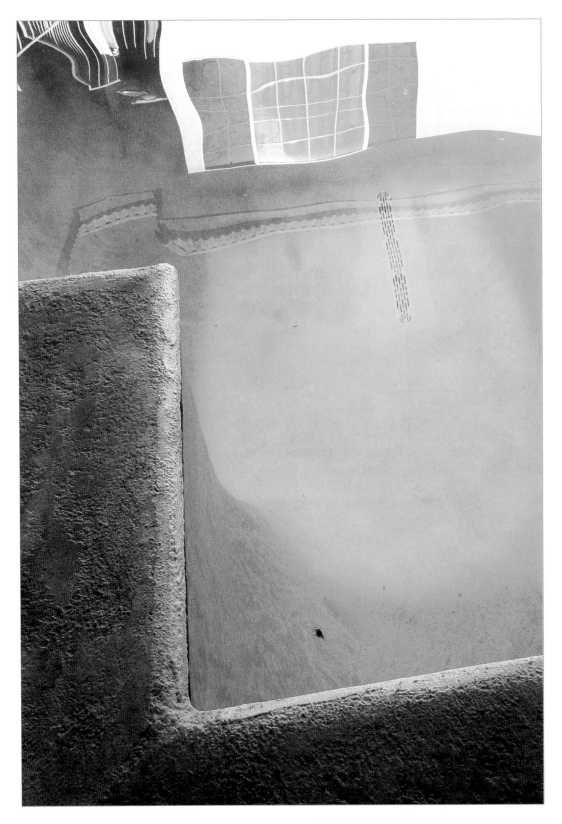

Comic Book Style

These still life images were made with an app called Clip2Comic.

Art Nouveau

Art nouveau is a decorative style. Line is important and often accents intricate design. The style's still life designs are typically based on organic, natural and stylized forms, and commonly emphasize pattern.

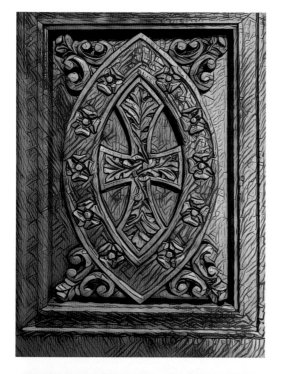

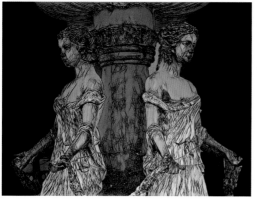

The Visionist app has many styles to choose from, doing a fantastic job of turning a photo into an image with an art nouveau style and many other styles, too. This still life of a bouquet of gladiola flowers set near family photo frames *(facing page)* was gorgeous. Visionist succeeded in accentuating their lines into a loose pattern. Not all of the selections will give the desired style. You must look through these selections and make a judgment about its affect on your still life. Ask yourself these questions. Does it create the style and look I want? Are the outlines strong enough, or too strong? What about the textures and colors?

The image of a cross is from a carved wood church door. It was a very light, honey colored, oak wood. Applying the selection in Visionist, changed the wood from honey to a warm walnut, with copper patina overtones. The outlines became more pronounced and the pattern popped to make it a very art nouveau design.

Each of these images, taken with an iPhone were transformed in the Visionist app.

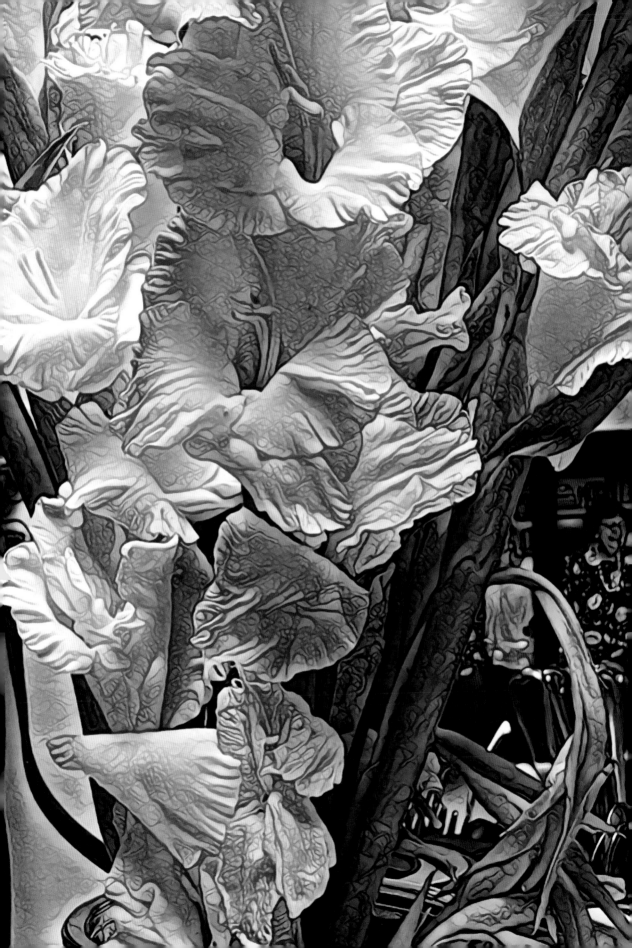

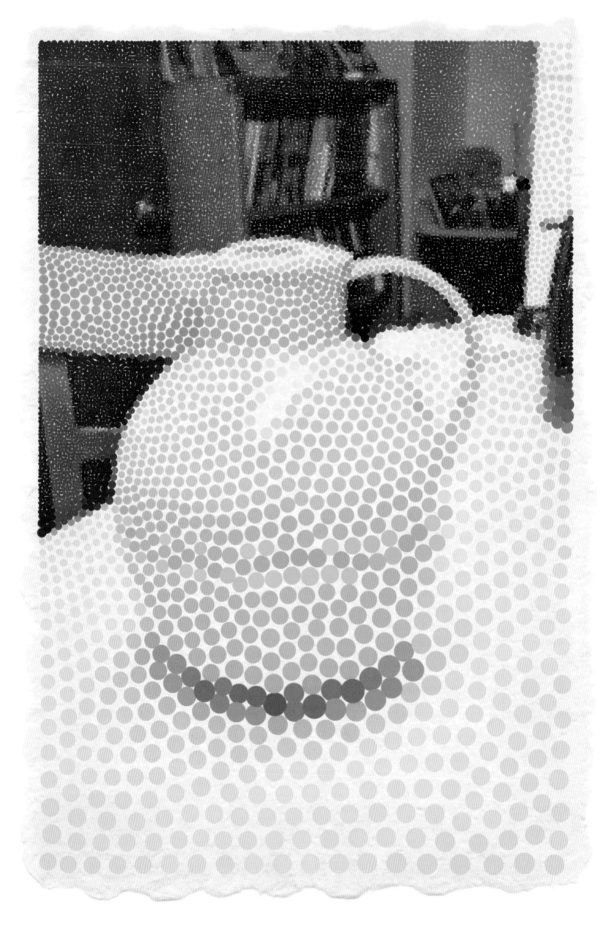

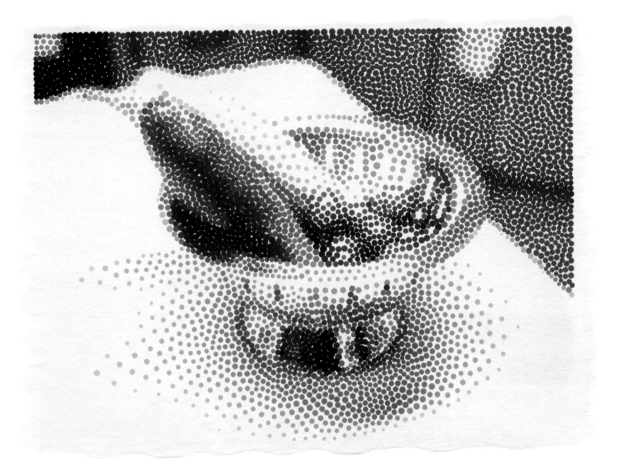

Pointillism

Stipple Effects

Pointillism is a neo-impressionist technique that uses tiny dots of pure color, which when viewed in its entirety, appears to be blended. This still life *(facing page)* is similar to how impressionists worked. The dots remain separate, unmixed spots of color.

Both of these images were photographed indoors with brightly diffused window light from multiple directions.

The stipple effect can look like pointillism, each dot having a clean and precise edge. Stippling was originally used in drawing, and for engraving by making marks. It was also used to create miniature paintings. There are several apps that can do stipple effects and pointillism, such as SnapDot, BeCasso, Deep Art Effects, Picas, and Visionist.

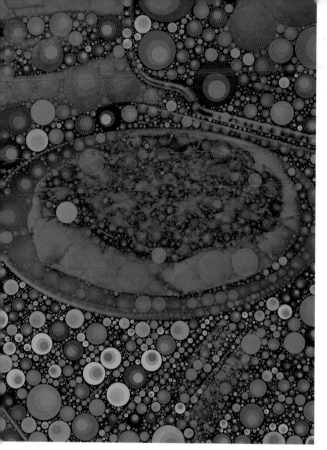

Percolator Pizza

Percolator is an app that produces effects similar to pointillism and stippling. However the dots are not always pure color or similar size. The app also allows the user to dial in an element of randomness, creating surprise outcomes.

These three still life images of a pizza cooked on an outdoor grill uses the same original photograph. The final depictions are very different. It shows how inexpensive and often free apps can produce still lifes

This still life's image file was imported into an app called Percolator. By choosing several variables, an assortment of looks can be achieved, from impressionism to op art to pop art, and more.

that are quite unusual. Images like these are not your traditional still life paintings, but they do reflect art of the 20th and 21st centuries. Think about Andy Warhol's Campbell soup cans. Images made with apps like Percolator show the impact that the iPhone and Android phones, and their apps are having on the world's creative arts.

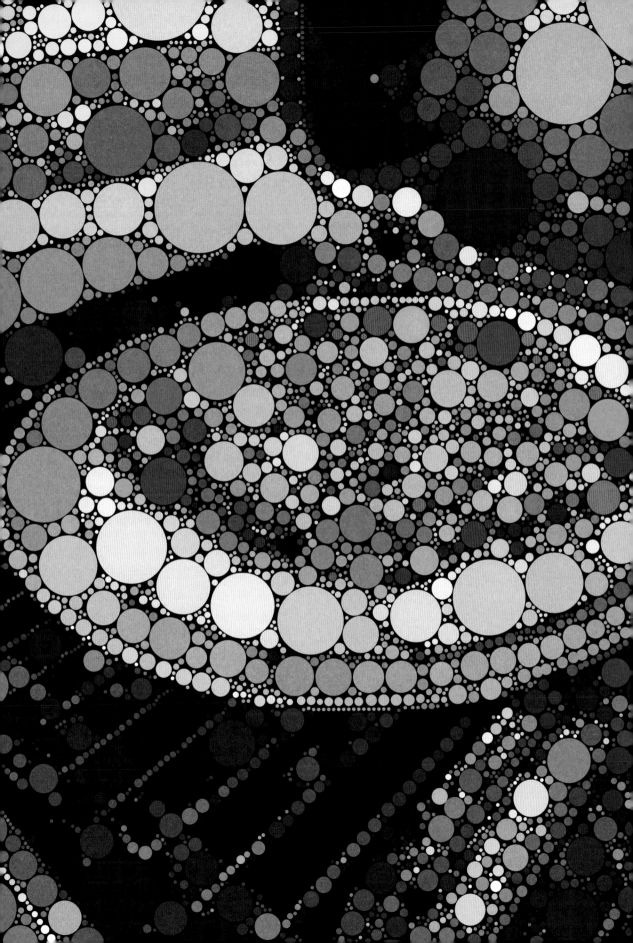

Fractured by Movement

The EFEKT app is all about fracturing an image based on the subject's movement. Consequently, an image

"The image is fractured or segmented depending on the camera or subject's motion."

can't be imported into the app, as is possible in nearly every other app described in this collection. It must come through the live camera. The image is fractured or segmented depending on the camera or subject's motion. The app is amazing for a still life that is in motion, but it has surprising affects for the truly still subjects, too, since it responds satisfactorily to the camera's movement just as well.

In the instance of a still life with motionless objects, the camera needs to be jiggled or bumped to initiate the effect. Some variations can be chosen such as wavelike and angular options, or the size of the fragments within the still life image.

These are photographs of the center console inside a car; each displays increased fragmenting. The last one *(facing page)* is so fragmented, it has become abstract.

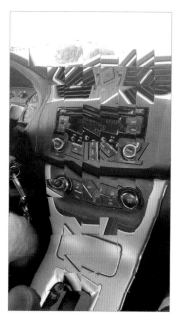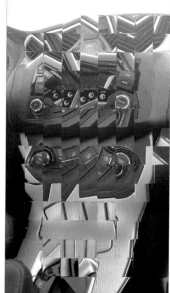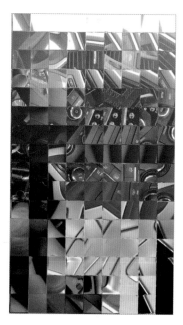

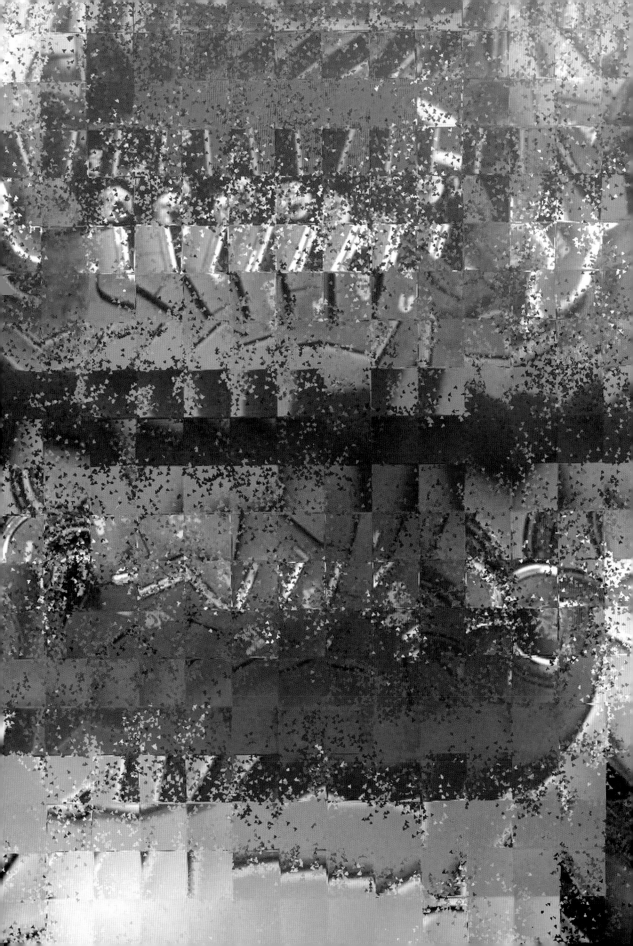

Print-Like Graphics

Print-like graphic images can be easily created by many of the apps. Gone are the days of painstaking work of creating a still life that is graphic in nature. No need for hours in the darkroom or printer's studio.

Starting with a good photograph is always helpful. However, many apps are extremely successful in emphasizing lines that in the initial photo were understated, creating textures that didn't really exist, and assigning successful and appealing color combinations to your still life. Needless to say, alternative forms of magazine style graphics are infinite. Subtle variations can be manipulated to match your graphic needs for whatever you require.

After photographing this still life, I realized that neither the color of the background nor the paper lining the basket worked, and the still life was no longer available to make changes to. So, I used the Visionist app to create a variety of images to choose from. It did a wonderful job of coordinating color and patterns throughout the image accentuating the textures of the basket and yarns.

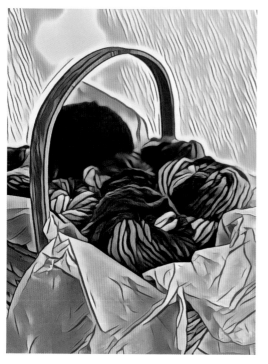 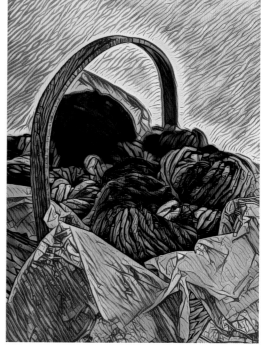

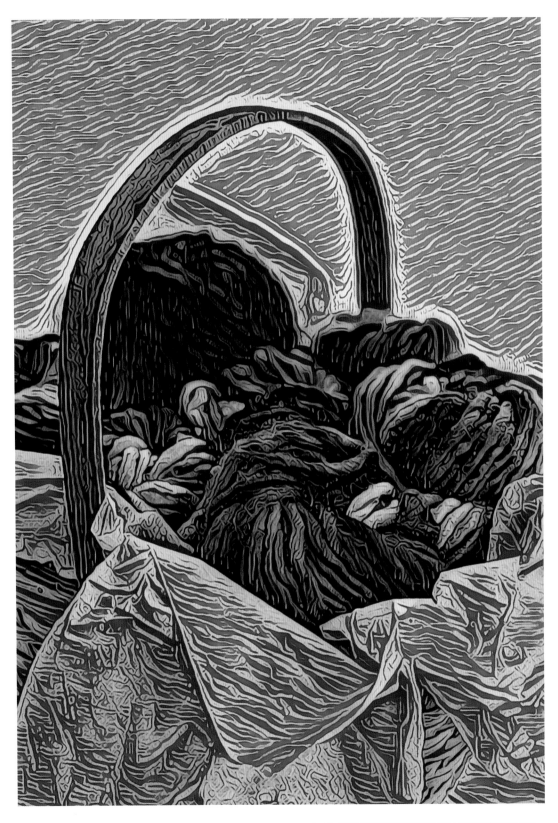

Wood Block Prints

Wood block prints are made with a relief pattern cut into a block of wood. The block can them be inked and pressed onto paper to make the image. This is a means of making multiple and identical copies, which was the state of the art for making reproductions for centuries before more advanced printing techniques were developed. Wood block printing technique has been used for centuries to make books, art, and illustrations. Usually one color of ink is used. However, additional colors can be used in more sophisticated works.

> *"A simple, yet strong still life was created by trying numerous selections in the Inkwork app, until finding just the right one."*

Although there are some works that have a fine degree of intricacies, most wood block prints have ample lines and substantial shapes. The print's simplicity is appealing. Today, we have an app that can make our smartphone images look just like wood block prints.

In the original still life photo *(above)* the strings are visible. However, in the finished image *(facing page)* the strings have more prominence and weight. A simple, yet strong still life was created by trying numerous selections in the Inkwork app, until finding just the right one. This app will also simulate other monochromatic forms of printing, too.

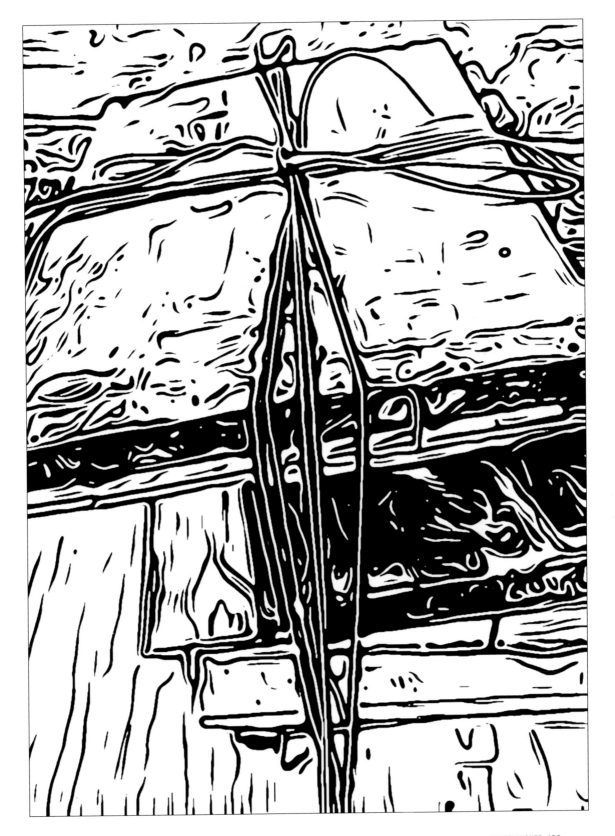

Print and Film Era Styles

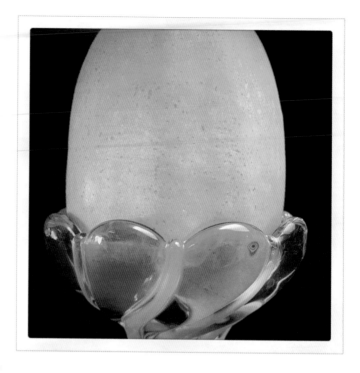

The early digital and pre-digital media has its own footprint that can be imitated using smartphone apps. These are characteristics that we want to maintain because they are our history and are now part of our culture—part of our creative vernacular. For example, I used the SnViewFX app to simulate the instant Polaroid photo of the 60s for the *Squash in a Crystal Bowl* still life. The app Thyra was used to apply halftone to the map still life. And, the app Noir was used for the *Bouquet on the Window Sill* still life.

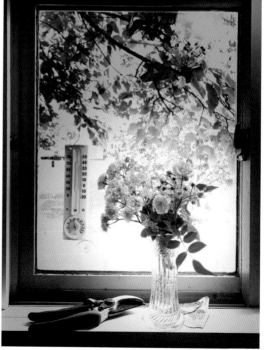

Glitch Art
Still Lifes

Glitch art uses either analog or digital mistakes to use aesthetically in the artistic process. Moire, mis-aligned pixels, ghost-ing, light leaks, lost channels, and more. A still life of a lost shoe can look rather intriguing. I used the app Glitchy Psyche-delic Camera VHS to produce each of these eight glitch effects.

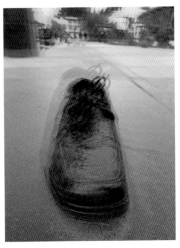
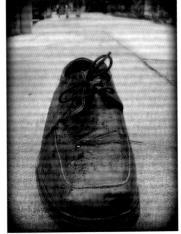

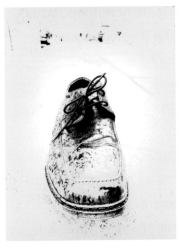
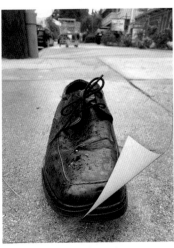
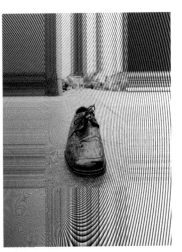

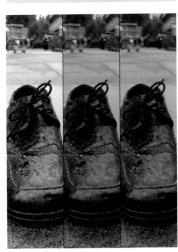
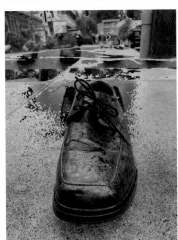
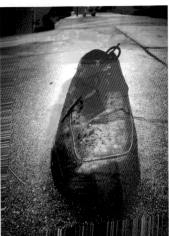

7 Still Life Narratives & Stories

With the hope of a good story, the viewer is lured into the world of a still life image.

Stories and narratives lure the viewer into an image. Objects that we choose to place in a still life can tell a story and create an emotive response in the viewer. We see things that are familiar, different, extreme, attractive, hideous, nostalgic, novel, polar, and emotive. Sometimes it is the objects that tell the story. Other times it is the composition that creates the force behind the message.

This image *(facing page)* was taken through an antique shop window. It shows a collection of old and previously owned items, which someone in the past had taken the time to make or choose and buy. Someone else had chosen to let go, or possibly an item was forgotten or not valued by subsequent generations. Each item in this collection holds the story of its creation, purchase, ownership, arrival in the shop, and placement among its flotsam companions. There is something in this collection that will look familiar to almost anyone, possibly evoking a sentimental or maybe other emotional response that speaks to the stories and narratives within us.

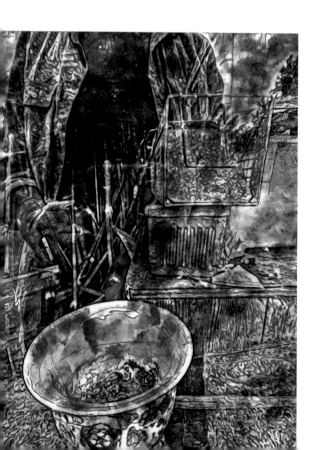

This image *(left)* was photographed through a shed window. Objects are inside, and my reflection is on the glass. A preset in the app Art Card was used to create the effects.

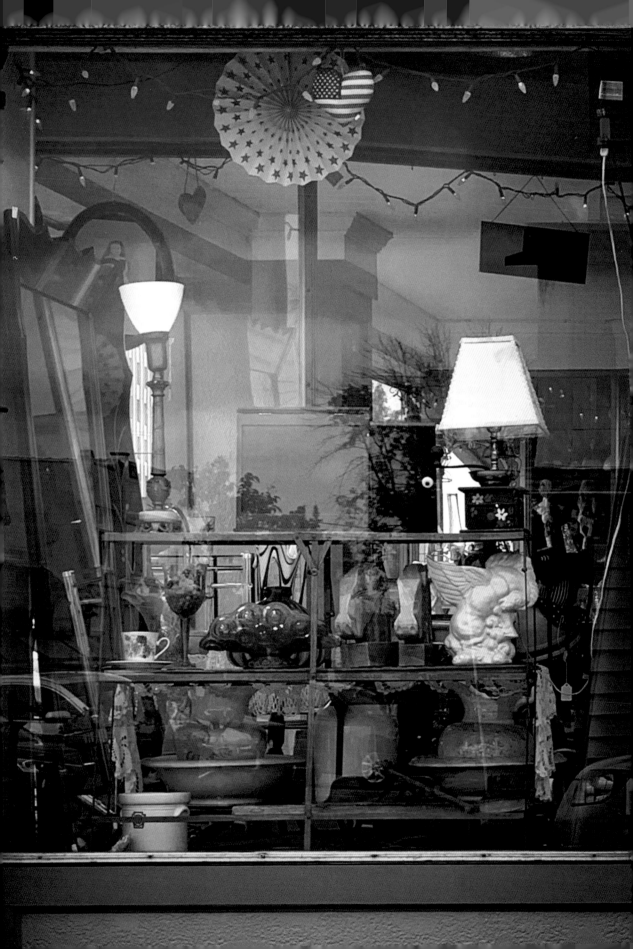

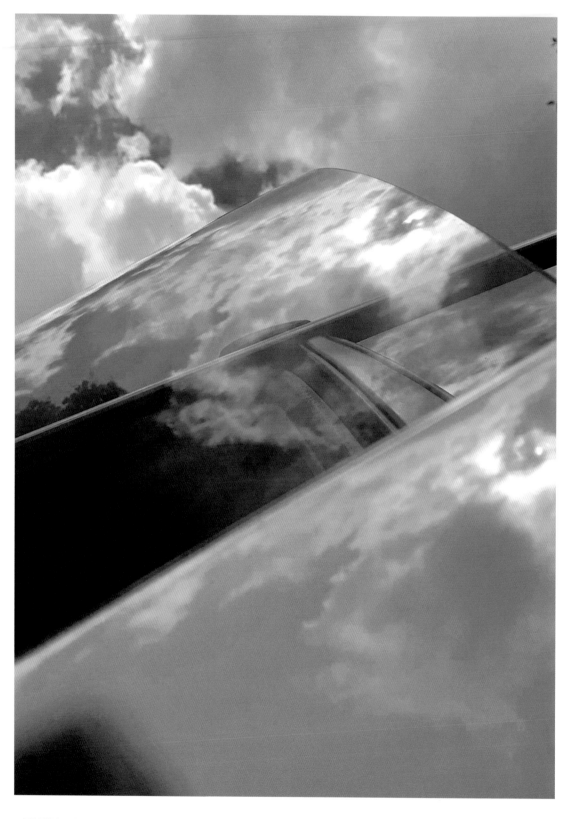

Visual Mysteries, Unraveling a Riddle

An image with contradictory or incomplete information is enigmatic—mysterious. Such an image teases us as we try to interpret and understand what we see. It will also persuade the viewer's eyes to linger and then reckon what is what.

This image *(facing page)* was not planned—it was mistakenly taken as my arms were full of packages. As I was tightening my grip on my

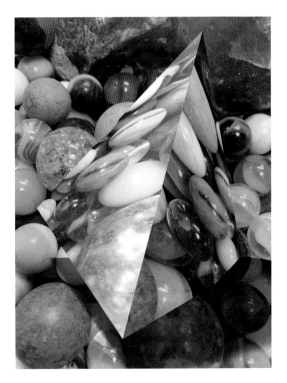

iPhone, the image was taken at an unusual angle. Then, the image was cropped, lights and darks adjusted,

> *"A visual paradox is a contradiction that the eye and the mind try to decipher."*

and a red filter applied. Finally, a tint was applied to give it a sepia tone.

These treatments to an already vague and somewhat unidentifiable image, make an image of heightened mystery—a puzzle to figure out. The viewer sees the outside because they see clouds and a silhouette of trees. And then questions: Am I looking through glass—maybe a curved window? The contrast of hard glass edges and soft clouds describes a discrepancy between the objects in the still life.

The facing page still life had minimal adjustments made to the image using the iPhone's native photo app's adjustments. The still life of marble *(left)* had minimal adjustments: increased saturation and sharpening. The prism was added using the app called Matter.

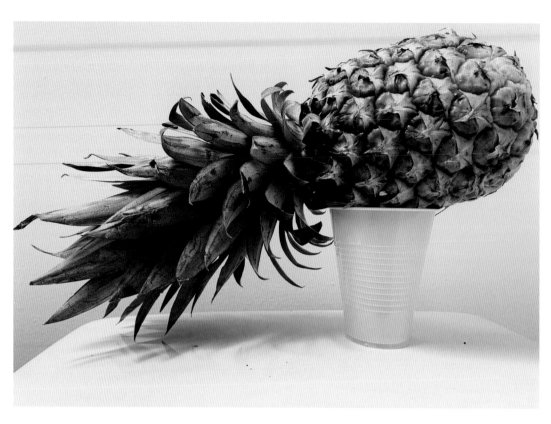

Contrast and Contradiction

The viewer is drawn to unravel the riddle behind still life imagery. An image with contradictory or incomplete information is enigmatic. The questions are: What do we make of this? Why is the pineapple placed on the porcelain in the lavatory? It presents a contradiction: a kitchen food item is in the wrong place. It also presents a contrast: an organic, textured, outside grown object sitting on a hard, manufactured, indoor object. Your image making choices can make your message strong and powerful or artful and subtle.

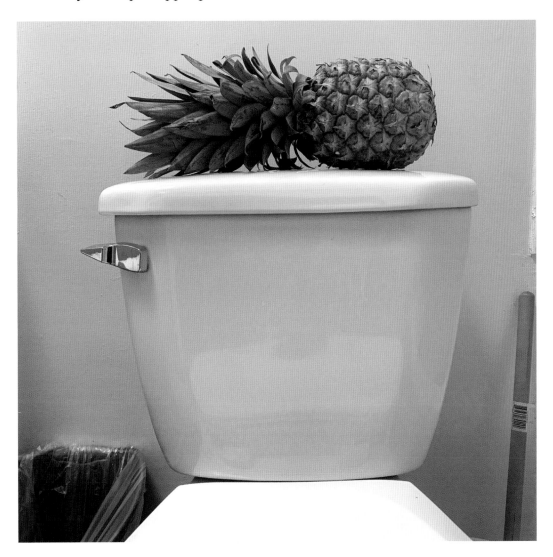

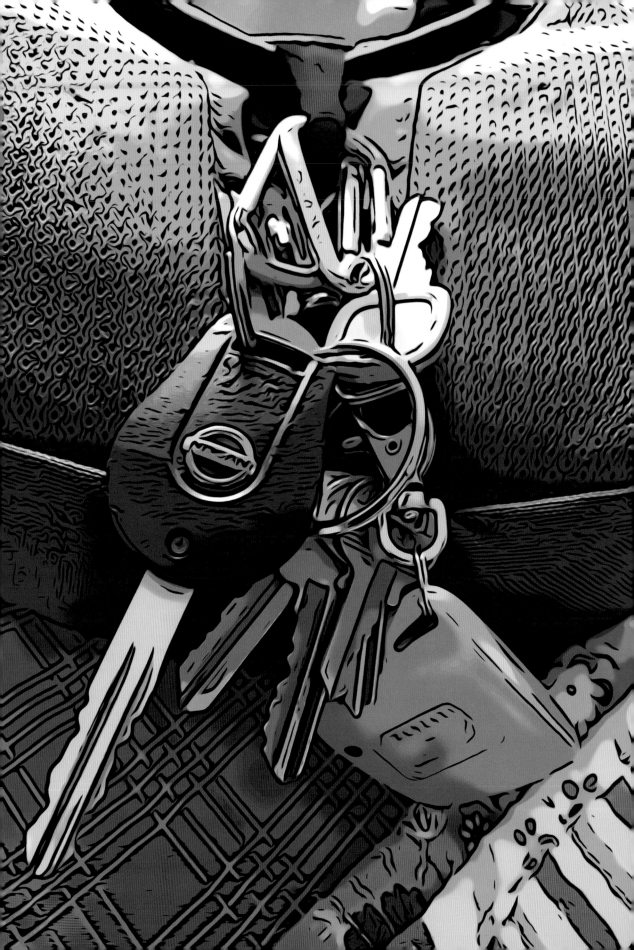

Show the Ordinary

Everyday objects are fascinating, as they tell the story of how we live, work, entertain, and enrich ourselves. The ordinary objects in our still lifes are a record of who we are and what we do, our values and our activities. These still lifes can be stark or beautiful, richly detailed or simple. It is up to each of us how we show the ordinary and give it meaning beyond our personal world by introducing it in an image to others.

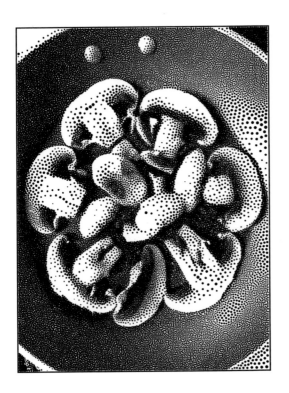

Pareidolia

Pareidolia is an images with often vague appearance, which to the viewer, looks to be something or someone they know. Humans have a tendency to interpret what they see as something they are familiar with, especially when what they see is indistinct. For example, an inanimate object may have two vague shapes and a line below. Consequently, it can appear to be manifestations of eyes and a mouth. Our need to find recognizable things in our world is one explanation of why this happens, such as a familiar face in a crowd or game when hunting in the forest. Nobody knows for sure why these patterns attract our attention, psychologically or otherwise. Pareidolia makes for interesting, and sometimes hilarious, still life images that can suggest a tale that needs telling. The fun can be comical and is unlimited.

Little was done to adjust the images below except to increase the saturation. The clothespins still life *(facing page)* was created in the Inkwork app. By emphasizing the linear characteristics of the objects in imported photo, legs, torso, arms, and heads are implied.

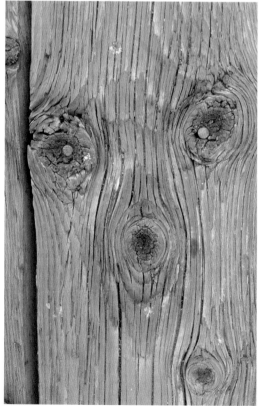

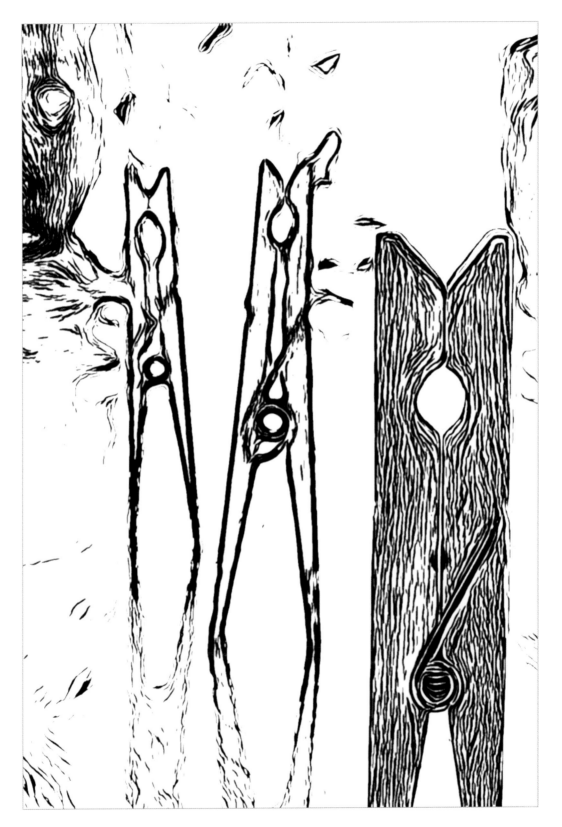

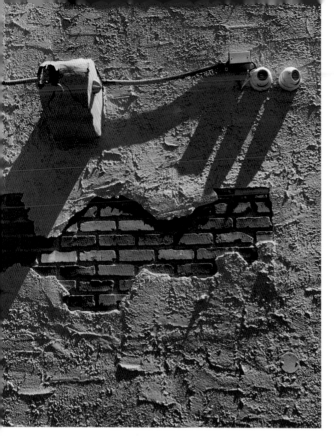

More Still Lifes with Personality

Lighting fixtures and stucco, a fallen leaf, a ball with printing, and a bathroom shelf with tissue paper rolls and hand towels make faces that compel us to take a second look. Point, shoot, and refine. Or, rework in one the many apps on your iPhone, iPad, or Android.

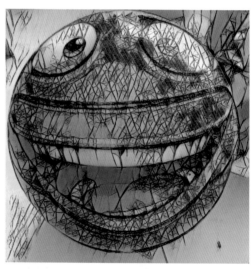

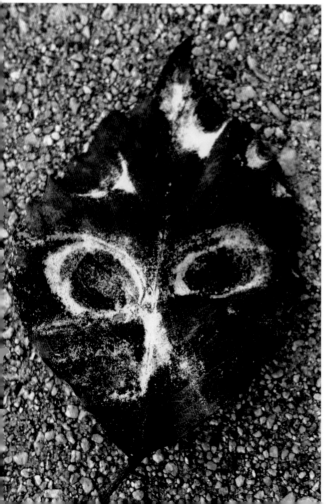

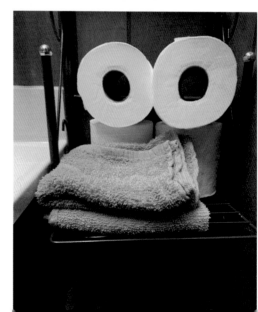

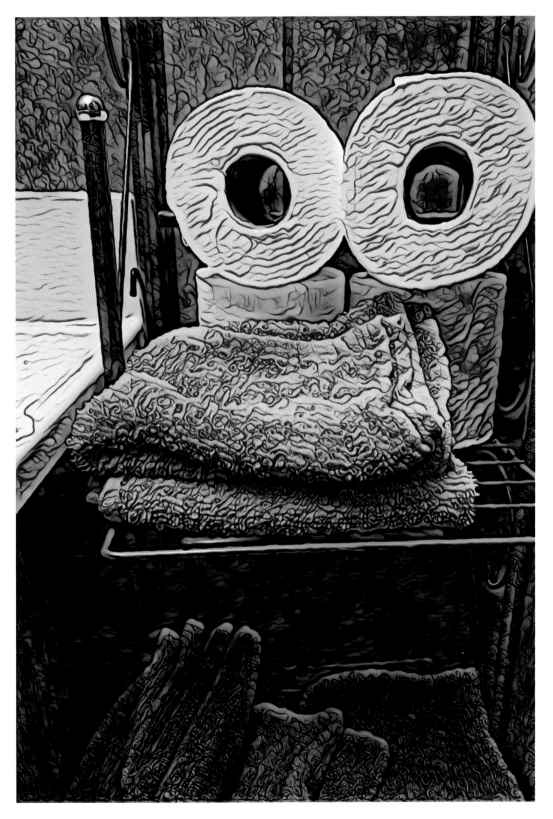

Explore, Create, and Share Your Still Lifes

The iPhone or other smartphone camera is quick, easy, and always with us. A still life is always near us too. Whether we purposefully set up a still life or use what is naturally in our surroundings, a still life is always handy to explore, create, and share. Use still lifes to show fascinating items, explore favorite objects, or display a product you make or sell. Share what you create with others. It will be very rewarding, and your skills will grow and develop. The meaning and enjoyment that others can get from still lifes should be remembered, too. So as you continue to work, don't forget to display, print, or publish your work, not only for others to appreciate, but for your own enjoyment, as well.

This image was photographed with diffused north light. The moire effect on the grassy area was made by the screen door material. It implies planting rows and suggests a farm. This nostalgic impression is furthered with the inclusion of the high-backed antique chair.

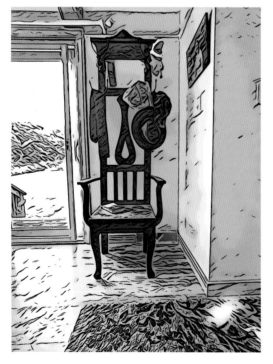
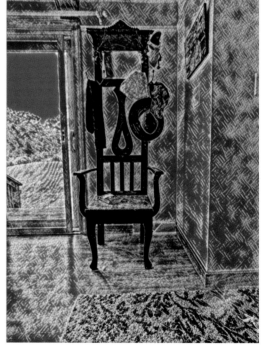

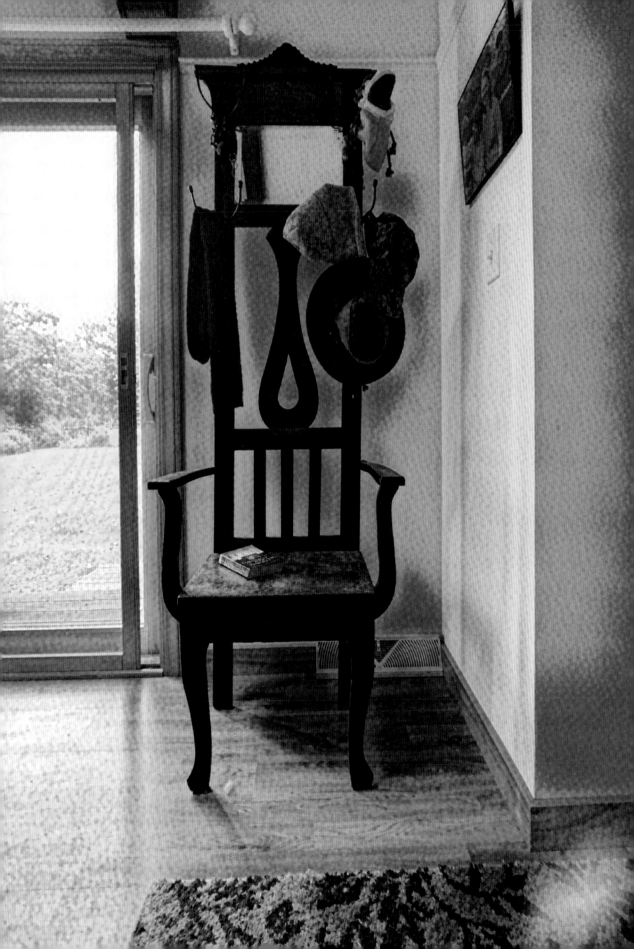

App List

This list offers general classification of apps but does not reflect there full potential. Many of the apps listed are in more than one category. Many more apps deserve to be on the list and many in more than one or two categories as they have multiple capacities. New apps are being always being created and existing apps are often refined and updated. Have fun discovering, exploring, and creating!

Dedicate Camera Apps

Camera+2
EFEKT
Halide
Moment
Pixlr
ProCamera
Slow Shutter
VSCO

Image Refinement

Adobe Lightroom
Adobe PS Express
Adobe Photoshop
Adobe Photoshop Mix
Curves
Darkroom
Noir
Snapseed

Lighting Effect Apps

LensLight
Light Ray 2
Mextures
Rays

Camera and Image Tool Apps

Handy Photo
Straightener
ViewExif

Traditional Art Media Simulating Apps

ArtCard
BeCasso
Deep Art Effects
My Sketch
Pic Sketch
Picas
SnapDotStipple
Waterlogue

Artistic Styles and Effects Apps

ArtCard
BeCasso
Glitchy Psychedelic
 Camera VHS
MOLDIV
Visionist

Image Manipulations Apps

Kansulmager
Gloomlogue
Matter
Tangled FX

Layers and Filter Apps

DistressedFX+
Formulas
Pixlr
Snapseed

Index

A

abstract art, 23, 94, 104
advertising, 6
apps list, 127
apps, native, 8, 14,
 44, 65, 115
art movements, 86–111
Art Nouveau, 98–99

B

backlight, 42
black & white, 38, 40,
 64–65, 67, 94,

C

cloud storage, 12
color, 23, 32, 33, 38, 40–41,
 42, 44, 64, 67, 79, 84, 94,
 98, 101, 102, 106, 108
comic book style, 40, 96–97
complexity, 26, 57, 91, 94
contrast, 14, 22, 40, 44, 65,
 81, 84, 94, 115, 117
curves, 29, 30–31, 115

D

digital art, 89
digital media technology, 6,
 58, 89, 110–111
drawings, 46–47,
 78–81, 101

E

effects, 59,73, 101
effects, out of camera, 14

F

fine art expression, 6
filters, 5, 9, 14, 22, 23, 50, 58, 59, 65, 115
focus, 8, 14, 16, 19, 68
formulas, 63
fragmenting, 104

G

genres, artistic, 6
glitch art, 111
graffiti, 76

I

illustration, 6, 108–09
Impressionism, 86, 101, 102
iPhone, 5, 6, 8, 9, 12, 14, 16
iPad, 5, 8, 13, 25, 91, 122

L

leading lines, 30, 33
lighting, sunlight, 13, 42, 44, 48, 50, 59
lighting, diffused, 39, 44, 46, 50, 86, 101, 124
lighting, window, 19, 20, 42, 46, 48–49, 50, 92, 94, 101
lighting, DIY, 52–53
lighting, candlelight, 54–55
lines, 29, 30–31, 32, 33, 71, 78, 98, 106, 108, 120

M

minimize, 23, 27, 44
monochromatic, 108
movement, 13, 104–05

N

narrative, 112–124

O

objects, 5, 6, 8, 10, 19, 20, 22–23, 26–27, 32–33, 34, 36, 39, 40, 42, 46, 53, 55, 57, 81, 104, 112,115, 117, 119, 120, 124
oil painting, digital, 84–85

P

pareidolia,120–123
patterns, 23, 32, 34, 39, 46, 94, 98, 104, 108, 120,
Percolator app, 102
print-like graphics, 106
proportion, 6, 23
Pointillism, 101, 102
Pop art, 88

R

realism, 90–95
reflections, 6, 14, 26, 56–57, 70–71, 84–85, 94, 112
repetition, 32–33

S

saving files, 12, 14, 84
series, 24–25
simplicity, 27

Snapseed app, 9, 14, 22, 23, 39, 42, 58, 59, 65, 67, 71, 75
stipple effect, 12, 101
story telling, 6, 39, 48, 57, 112–123
subjects, 6, 8, 10, 16, 19, 20, 22–23, 25, 26, 27,30, 34, 57, 58, 83, 86, 104
Surrealism, 90–91

T

Tangled FX app, 9
textures, 6, 20, 23, 26, 34, 38–39, 46, 53, 63, 74–74, 76–77, 94, 98, 106, 117
themes, 22–23
tripod and monopod, 10, 61, 19, 20, 23, 55, 71

V

vignettes, 27, 39, 59, 63, 68–69, 76–77

W

wood block print, digital, 108–09
watercolor, digital, 82–83

AmherstMedia.com

- *New books every month*
- *Books on all photography subjects and specialties*
- *Learn from leading experts in every field*
- *Buy with Amazon (amazon.com), Barnes & Noble (barnesandnoble.com), and Indiebound (indiebound.com)*
- *Follow us on social media at: facebook.com/AmherstMediaInc, twitter.com/AmherstMedia, or www.instagram.com/amherstmediaphotobooks*

Create Pro Quality Images with Our Phone Photography for Everybody Series

iPhone Photography for Everybody

Black & White Landscape Techniques

Gary Wagner delves into the art of creating breaktaking iPhone black & white landscape photos of seascapes, trees, beaches, and more. $29.95 list, 7x10, 128p, 180 color images, ISBN 978-1-68203-432-3.

iPhone Photography for Everybody

Artistic Techniques

Michael Fagans shows you how to expertly use your iPhone to capture the people, places, and meaningful things that color your world. $29.95 list, 7x10, 128p, 180 color images, ISBN 978-1-68203-432-3.

iPhone Photography for Everybody

Landscape Techniques

Barbara A. Lynch-Johnt provides all of the skills you need to master landscape photography with any iPhone. *$29.95 list, 7x10, 128p, 160 color images, ISBN 978-1-68203-440-8.*

Phone Photography for Everybody

Family Portrait Techniques

Neal Urban shows you what it takes to create personality-filled, professional-quality family portraits with your phone. $29.95 list, 7x10, 128p, 180 color images, ISBN 978-1-68203-436-1.

Phone Photography for Everybody

Still Life Techniques

Beth Alesse provides creative strategies for artfully photographing found objects, collectibles, natural elements, and more with a phone. $29.95 list, 7x10, 128p, 160 color images, ISBN 978-1-68203-444-6.

Phone Photography for Everybody

iPhone App Techniques— Before & After

Paul J. Toussaint shows you how to transform your iPhone photos into fine art using an array of free and low-cost, simple apps. $29.95 list, 7x10, 128p, 160 color images, ISBN 978-1-68203-451-4.